magic with photography

Simplified Explanations and Scientific Demonstrations
of Basic Photography

by EDWARD L. PALDER

illustrated by RIC ESTRADA

Collins • *London and Glasgow*

ISBN 0 00 106148 8
PRINTED AND MADE IN GREAT BRITAIN BY
WM. COLLINS SONS & CO. LTD.
LONDON AND GLASGOW

contents

Contents

Contents

scientific experiments with photography

introduction

There are many people who have yet to learn that there is more to photography than just putting film in a camera, aiming it at a subject, and pressing the shutter. That is only the beginning. This book was written for the beginner in order to simplify the explanation of photography and photographic methods.

By learning and doing what is explained in this book, you will find that photography is a fascinating hobby and that there is no end to the interest and fun that can be had with it. Photography has always been a popular hobby, and during the past few years there has been an increase in the number of people who want to learn how to take better pictures. Many have learned that photography is a universal language and that photographs are a way of preserving wonderful memories.

The following pages contain thirty-five safe experiments that can be done alone by amateur scientists or under the supervision of parents or teachers. The experiments have been tested by the author, and the directions are simple and complete. Most of the equipment can be found around the house or made from scrap materials. Necessary chemicals can be purchased at the chemist, and some can be found at home. Some of the materials can be purchased from a photographic dealer.

It is a lot of fun to work with experiments that explain photography. Your laboratory can be the basement, the kitchen, or even your bathroom. This book was written primarily to show that photography, as a hobby, has much to offer in the way of recreation and learning—and there is no better way to learn than by having fun while doing it.

Edward L. Palder

the story of photography

Photography, a Science and an Art

The science of photography is as modern and fast changing as your daily newspaper. Seldom do a few days pass when something new has not been discovered. It might be a new kind of camera, an improvement in the processing of pictures, or an idea for using present equipment to make better pictures.

Simply explained, photography is the science and art of making pictures by exposing light-sensitive materials to light. Anyone who knows and understands the science of photography might be able to take pictures that are technically perfect. However, these pictures might lack artistry if little or nothing is known about art. To be a good photographer, one must know not only the science but also the art of photography.

Primitive Man and the First Pictures

Photography had its beginning about 170 years ago when it was discovered that lenses, light, and certain chemicals could be used to make pictures. However, there is historical evidence going back thousands of years showing that very early races of man who lived in caves made the first pictures.

These pictures are mentioned because of their historical significance in showing man's earliest efforts to preserve knowledge. Using crude, primitive artistic techniques, man accidentally discovered how to make simple dyes and paints from the juice of berries and earth colours mixed with animal fat. Scientific research reveals that these ancient picture records of the prehistoric period were made by first carving them into stone and then colouring them. These pictures are often the only evidence we have about life and customs of the prehistoric age.

The Early History of Photography

Around A.D. 500, men working with the mysteries of science were known as alchemists, and during the Middle Ages science, known as alchemy, became a combination of chemistry, magic, and superstition. Many alchemists were interested only in the "magical" results and not in the scientific understanding of their experiments.

Because of superstition and lack of knowledge, chemistry, for hundreds of years in the Middle Ages, made little headway, and many of the discoveries were kept secret and were lost or destroyed. However, some knowledge and

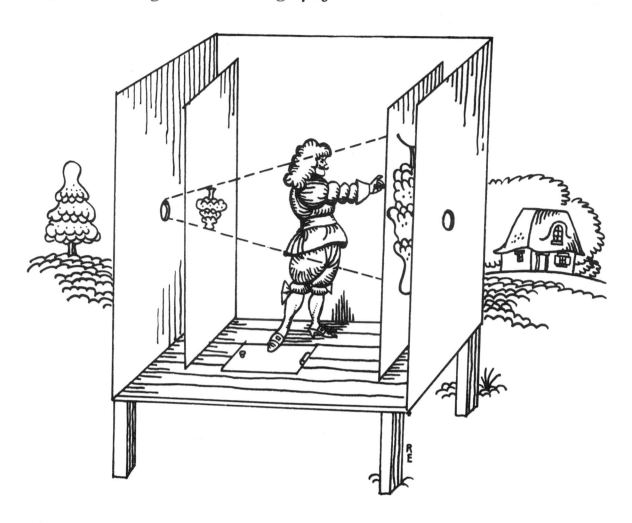

equipment preserved from this era have had an influence on the science of photography as it is known today.

In the eighth century, a discovery which was to have a great influence on photography in later years was made by Jabir Ibn Hayyam, an Arabian alchemist. He observed that sunlight caused certain silver compounds to darken. During the early part of the eleventh century, another Arabian scientist recorded information about the use of equipment that can be described as being the first camera. Known as the

Camera Obscura, it consisted of a dark box (or darkened room) with a small opening in the centre of one side through which light was admitted. Rays of light which reflected from different objects outside the Camera Obscura entered through the opening and formed an image (picture) on the far side.

Chemical Research in the 18th Century

Historians often call the 1700's the Age of Reason because the ideas and con-

cepts of science began to change rapidly. People began to make greater use of their ability to think as they continued to search for answers to scientific problems and to apply this knowledge to everyday life. Many of the experiments of the alchemists were repeated, only this time they were done in a more organized way and under controlled conditions.

Among these early chemists was Johann Heinrich Schulze, who experimented with light and its effect on chemical compounds. In 1727, he repeated the experiment in which light caused silver compounds to darken. Although Schulze was a scientist of great ability, he was unable to discover why a solution of chalk and aqua regia (nitric and hydrochloric acids) mixed with silver turned purple when exposed to light.

Thomas Wedgwood and Sir Humphry Davy

In 1802, seventy-five years after Schulze performed his experiments, two Englishmen, Thomas Wedgwood and Sir Humphry Davy, realized the importance of this experiment. They used it to make the first photographic pictures. They began by treating sheets of paper with solutions of silver chloride and silver bromide and letting them dry. Next, they put a sheet of the chemically treated paper in a darkened box which had a lens from a telescope in an opening at one end. They placed the box in the sun, and any light passing through the lens formed an image that came in contact with the paper. When the paper was removed it was observed that wherever the light had come into contact with the paper, the silver salts had darkened to make what was referred to as a "sun picture."

Since it was not known how to make these pictures permanent, they eventually faded, and these photographs were lost in the antiquity of photographic history.

W. H. Fox Talbot

In 1835, a method for preventing sun pictures from fading was discovered by W. H. Fox Talbot. He discovered that light-sensitive sun pictures could be "fixed" (made permanent) by treating them with ordinary salt.

Until 1840, all photographs were negatives in which the tone values of the object were reversed (black appeared white, etc.). Talbot discovered that chemically treated sheets of thin transparent paper could be used to make photographic negatives. He placed a negative in contact with a second sheet of light-sensitive paper and exposed them both to light. Using this method, Talbot made a positive picture in which the tone and colour values of the object appeared as in the original object (white was white; black was black).

A year later Talbot discovered that certain chemical compounds could be used to replace the long period of time that was necessary when exposing light-sensitive materials. He discovered how silver salts could be exposed for a very short time, so short that no change could be seen. He then treated the exposed plates with a chemical known as pyrogallic acid to make the picture visible. This process became known as developing.

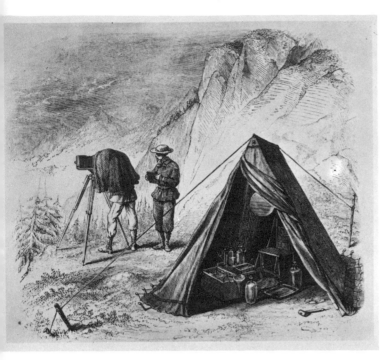

The wet-plate photographer of the 1860's had to carry his darkroom and chemicals with him in order to develop his plates before the emulsion dried.

Sir John Herschel

Around the middle of the 19th century, Sir John Herschel, the astronomer, discovered that hypo (sodium thiosulphate) instead of salt could be used to fix photographic negatives and positives. This proved to be better than Talbot's method and is still used today.

It is of interest to note that although we have used the word photography many times, it was Sir John Herschel who used it first.

Joseph Niepce and Louis Daguerre

Around the time that Talbot was making his discoveries, a French physicist, Joseph Niepce, was experimenting with a process of making photographs using chemically treated metal plates.

Niepce died before he finished, and his work was continued by Louis Jacques Daguerre, a French artist. Named after its inventor, the first Daguerreotypes were made in 1839. Daguerre exposed polished copper plates coated with silver to fumes of iodine. This changed the silver to light-sensitive silver iodide. After the plates were exposed to light, using a camera invented by Niepce, the pictures were developed by exposing the plates to mercury vapors. They were then made permanent by dissolving the unreacted silver iodide with potassium cyanide.

Daguerreotypes, however, made only one copy of each picture. Talbot's negatives could be used to make several copies of the same picture, but they lacked quality when compared to Daguerreotypes, which were more permanent. The next step was to find a method for making pictures, using the advantages of both Daguerre's and Talbot's methods.

The Wet-Collodion Process

Pictures made from paper negatives were not the best, and to improve their quality many different materials and methods were tried. In 1851, Frederick Scott Archer, an English architect, discovered how to deposit a layer of light-sensitive chemicals on sheets of thin glass. Known as the wet-collodion process, this method consisted of using a mixture of silver salts and collodion to coat sheets of glass. Photographic

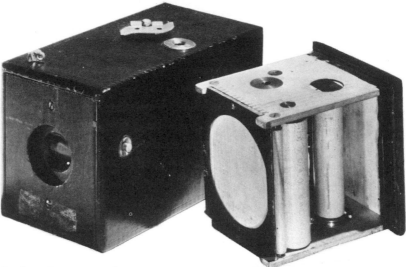

The No. 1 Kodak, introduced in 1888, sold for £10. When all the film had been exposed, the owner shipped the camera back to the factory, where the film was developed and printed and the camera reloaded for a cost of £4.

plates made this way had to be exposed and developed before the collodion mixture dried.

This was a disadvantage because the light-sensitive plates could not be prepared in advance. It was necessary for the photographer to set up a temporary darkroom in order to prepare and develop these plates. Although they were difficult to handle, the process produced excellent results and was used for many years.

Bolton and Sayce

During the next thirty years, the wet-collodion plates of Archer were the best available. In 1864, two American chemists, W. B. Bolton and B. O. Sayce, experimenting with light-sensitive compounds, substituted silver bromide for the compounds being used. Even today, silver bromide is used more than any other light-sensitive compound.

Invention of the Dry Plate

The year 1871 was a significant one. An

English chemist, Dr. Richard L. Maddox, announced the discovery of a method by which the glass plates of Archer could be made in a dry form. After trying many different materials to hold the light-sensitive silver bromide onto the plates, Maddox accidentally discovered that ordinary gelatin could be used. Glass plates coated with silver bromide and gelatin could be prepared in advance, stored until they were to be used, exposed anywhere, and then placed aside to be developed at a later date. Maddox's discovery was one of the most important advances and was the forerunner for the development of present-day photography.

George Eastman

The end of the 19th century marked the

beginning of photography as it is known today. It became a science easily understood by everyone. In 1888, George Eastman introduced the flexible roll of film and a simple camera in which it could be used. Instead of glass, Eastman used celluloid on which he coated the light-sensitive silver compounds.

With the introduction of Eastman's roll film, millions of people became interested in photography, as illustrated by the number of cameras manufactured and sold. To take a picture, the camera was aimed at the subject and the shutter was pressed. The film was wound a certain amount after each exposure in order to take another picture. After all the film had been exposed, the camera was sent back to the manufacturer, who removed and developed the film. The finished pictures were returned with a new roll of unexposed film inside the camera.

Today

We still use the film invented by George Eastman. Only the light-sensitive chemicals used in making the film have been improved. Today's photography is a science that has been developed from research and improvement of the discoveries made by pioneers. The basic principles of the camera Eastman invented in 1888 are still used in the modern cameras of today. The only changes are improvements and modifications needed to adapt a camera for a specific use. The field of photography is immense, but quite a bit of it remains unexplored. Perhaps one of you who are interested in photography will make a discovery that will take us a step further.

Kodak's first folding camera, produced in 1890, held a roll of film adequate to make 48 4 x 5 pictures.

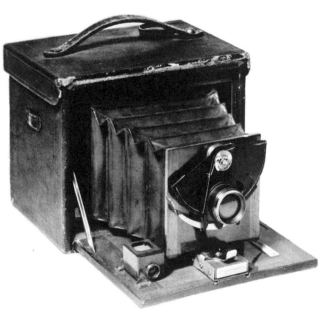

the why and the how of photography

What Is Photography?

Photography is the science of the composition and properties of light-sensitive materials. It is also the study of how to expose these substances to light and then treat them with chemicals to make photographs. Photography is concerned with many subjects—*Optics,* the light we use to make a photograph; *Chemistry,* the chemicals used to make film and those used to develop it; *Mechanics* and *Physics,* the camera and equipment used to take the picture; *Imagination* and *Knowledge,* the artistic and scientific information needed to obtain the photograph wanted.

In the years that have passed since 1802 when Thomas Wedgwood and Sir Humphry Davy made the first photographic pictures, photography has grown, with ideas and equipment that stagger the imagination when compared to the simple equipment of the 19th century. Photography is now a science that anyone can understand and is no longer a specialized field limited to highly trained scientists.

Photography Is Part of a Chemical World.

Many chemicals must be kept in dark-coloured bottles or light-proof containers to protect them from being spoiled by exposure to light. Some of the more familiar materials sensitive to light are certain cosmetics; chemicals such as hydrogen peroxide, antiseptics, disinfectants, and vitamins; household products such as instant coffee, herbs and spices, laundry bleach, etc.

There are many chemical reactions that will not take place unless light is present. Chemical compounds that change when exposed to light are called photochemical compounds and the branch of chemistry that includes these reactions is known as PHOTOCHEMISTRY. Photochemistry not only includes photography, but also the effect light has on other materials. You have noticed how coloured materials fade in the sunlight. You know how your skin tans or burns when sitting in the bright sun. Do you know that photosynthesis, the process in which plants absorb carbon dioxide from the air and water from the ground to manufacture food, will not take place unless sunlight is present?

Another example of a photochemical reaction is the change that takes place in some silver compounds. Light can change certain silver compounds to metallic silver.

EXPERIMENT

Effect of Light on Hydrogen Peroxide

MATERIALS: Two test tubes; two small jars (beakers); cellophane tape; black paper; two stands with test tube holders; wooden splints; 3% hydrogen peroxide; matches.

WHAT TO DO: Cover a test tube and one of the jars with black paper making them light-proof. Use cellophane tape to hold the paper in place. Leave the mouths uncovered.

Fill both jars three-fourths full with hydrogen peroxide. Fill the test tube covered with paper with peroxide and then cover the mouth with your thumb. Invert the test tube and place it about one-half inch below the surface of the peroxide in the covered jar. Hold it in place using a stand and test tube holder. Using black paper, cut a cover with a hole in it through which the test tube will just fit and use it to cover the mouth of the jar. Repeat this procedure with the uncovered test tube and jar. Do not cover the mouth of this jar.

Place both jars in bright sunlight for two to three hours. At the end of this time, using the same method as when placing the test tubes in the jars, remove one at a time. Before you remove the test tubes, have ready a glowing splint. Turn the test tube upright and quickly place the glowing splint inside. Do not put it below the surface of any liquid that might remain. Repeat this with the other test tube and compare the results.

WHAT HAPPENS: Examination of the test tubes after standing in sunlight reveals that a gas has collected at the top of the tubes, replacing some of the peroxide. There is more gas in the tube that was left uncovered. Placing a glowing splint into the gas caused the splint to burst into flames. This is a specific test for oxygen. In the test tube that was covered, there was little, if any, reaction to the glowing splint. This experiment proves that the energy in sunlight can cause hydrogen peroxide to break down to form oxygen.

EXPERIMENT

Exposing Coloured Materials to Light

MATERIALS: 2-inch squares of different coloured paper; 3-inch squares of black construction paper; cardboard; library paste.

WHAT TO DO: Paste coloured squares of paper on a sheet of cardboard. Cover a portion of each square with a square of black paper. Make two identical sets.

One set should be put away in a dark closet or drawer and the other placed in bright sunlight. After several days remove the black squares of paper. Examine the covered areas of both sets and compare them to those left uncovered.

WHAT HAPPENS: On the set left in the sunlight, the areas not covered with black paper will show some fading. The set kept in the dark shows no fading. Comparing the two sets proves that sunlight is a source of energy that can cause dyes in some materials to fade.

EXPERIMENT

Light Changes Silver Compounds

MATERIALS: 10% silver nitrate solution (from the chemist); white paper; applicator sticks.

WHAT TO DO: *Be extremely careful not to get any of the silver nitrate on your skin or clothes. . . . Stains that are very difficult to remove will result.*

With applicator sticks draw a series of lines and dots with the silver nitrate solution on white paper. Prepare two similar sheets. Place one in a dark cupboard and the other in bright light. After an hour compare both sheets of paper.

WHAT HAPPENS: The silver nitrate exposed to light turns dark. The silver nitrate kept in the dark shows no change. This is proof that light can cause a change in silver compounds. How this is used in photography will be explained later.

Energy and Chemical Changes

Energy is always involved whenever changes occur in different materials. In using a torch, the stored chemical energy in the batteries produces electrical energy which is quickly changed to light energy. Using physical energy, we can strike a match to produce light energy. The light (flame) can be used to produce heat energy or, using special apparatus, it can be converted into electrical energy. It was mentioned before that photosynthesis will not occur unless sunlight is present. It is the light energy in sunlight that is utilized in this process.

Science has proven that energy cannot be destroyed, but can be changed from one form into another. This is what happens in photography. When blueprint paper is exposed to light, a change takes place. When the shutter of a camera opens, light is allowed inside and quickly flashes on the light-sensitive film. The light rays strike the film, and a chemical change takes place in the light-sensitive materials.

In blueprint paper, light energy changes a soluble chemical compound into an insoluble one. In light-sensitive film, the light reacts with the silver compounds, changing them to metallic silver.

EXPERIMENT

Changing Energy to Another Form

INTRODUCTION: This is primarily an experiment of observation of situations that surround us every day. The materials needed to duplicate what is observed might prove too expensive to purchase. It is suggested, however, that other energy transformations be looked for in addition to those described.

MATERIALS: As listed in WHAT TO DO.

WHAT TO DO: If you were to examine the inside of a torch battery, you would find chemicals that react to produce chemical energy which in turn is rapidly converted to electrical energy. To use this electrical energy, physical energy is required to connect the battery to the equipment the battery is going to operate. The electrical energy trans-

formed from chemical energy can be used to do a great number of things.

1 It can be used to make a bulb light and therefore change part of the electrical energy to light energy.

2 It can be used to run an electric motor, converting the electrical energy to mechanical energy.

3 Connecting the battery to a toaster or iron, the electrical energy can be changed to heat energy.

WHAT HAPPENS: Changing chemical energy is the result of chemicals reacting with each other, and when they do, electrons are transferred from one chemical to another. When this happens, electrical energy is created.

The discovery that chemical energy could be changed to electrical energy was made by Alessandro Volta in 1800. He found that when he placed metal disks of copper and zinc alternately in a pile, and separated them with a cloth wet with a solution of salt, the result was electricity. Any resemblance of the modern battery to Volta's voltaic pile of 1880 has been replaced by many advanced modifications.

In 1879, Thomas Edison produced the first practical lamp. He used electrical energy to heat a carbonized cotton thread placed in a high vacuum. The thread, called a filament, glowed intensely and produced light.

EXPERIMENT
How to Make a Simple Instrument to Measure Energy

MATERIALS: Magnetic compass; small cardboard box (slightly larger than the compass); insulated copper bell wire; dry cell.

WHAT TO DO: The instrument to be described in this experiment is called a galvanometer. It is a highly sensitive instrument that can be used to detect and measure electricity (electrical energy).

Wind five turns of copper bell wire around the box. Leave long enough ends so that they can be connected to the dry cell. Carefully place the compass inside the box so that the compass needle points in the same direction as the wire coils. Connect the wires to the dry cell. The needle will turn in a direction away from the coils.

WHAT HAPPENS: Any electricity passing through a coil of wire sets up a magnetic field that causes the needle of the compass to turn away from the wire coil.

In the next experiment, the amount of electrical energy produced is so small that a galvanometer must be used to measure it.

EXPERIMENT
Light to Heat to Electrical Energy

MATERIALS: Thin copper wire; thin iron wire; galvanometer; alcohol lamp.

WHAT TO DO: Carefully scrape clean about three inches from the end of each wire and twist them together. Clean about one inch from the opposite ends and attach to the galvanometer. The copper wire should be connected to one terminal and the iron to the other. Light

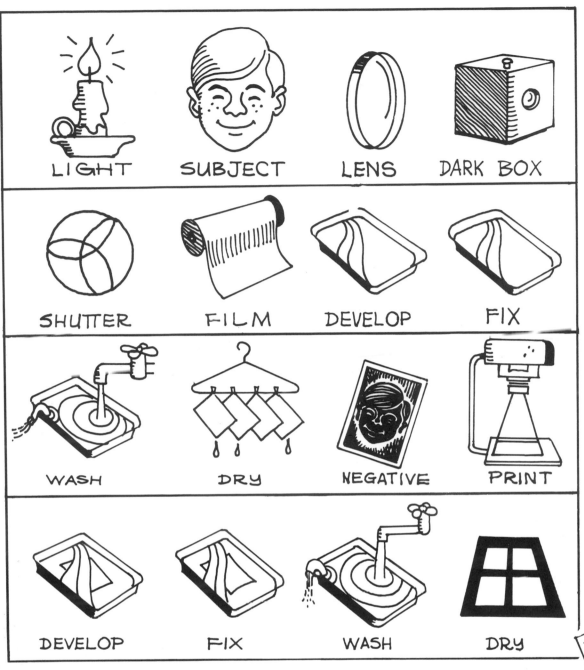

LIGHT	SUBJECT	LENS	DARK BOX
SHUTTER	FILM	DEVELOP	FIX
WASH	DRY	NEGATIVE	PRINT
DEVELOP	FIX	WASH	DRY

the alcohol lamp and heat the twisted ends in the flame. The compass needle should move, showing the presence of an electric current.

WHAT HAPPENS: Heating two different metals that are in contact with each other causes electrons to flow from one metal to the other. When there is a movement of electrons, electricity is formed as shown by the galvanometer.

SUGGESTIONS: It might be necessary to heat more than one copper and iron couple. The amount of electricity produced might not be enough unless more than one couple is used.

The ABC's of the Photographic Process

There are two steps to be considered when making pictures using photog-

raphy. The first concerns the use of the camera when taking the picture. The other is the laboratory work concerned with the developing of the film and the making of positive prints. Briefly the photographic process can be summarized as follows:

Light falls on the *object* being photographed, which *reflects* and *absorbs* part of the light. The *reflected light rays* are collected by a *lens* which *focuses* them to form an *image*. The amount of light allowed to enter the *camera* through the lens is controlled by the *shutter* and *diaphragm*. Once in the *camera,* the *light rays* strike the *film,* causing an *invisible change* in the light-sensitive *silver compounds*. This is the first step.

The second step begins when the camera is brought into a *darkroom*. The *exposed film* is removed from the camera and treated with a *chemical solution* known as the *developer* to form a *visible picture*. The film is next *washed in water* (or chemical solution) to stop the action of the developer. It is then placed in another chemical solution known as the *fixing bath* to remove any remaining, undeveloped silver compounds. Once more the film is *washed in water* and then *dried*. The result is a *negative* where the colour values of the object are reversed (black appears white; white is black).

The negative is then placed in contact with a sheet of *light-sensitive paper* and *exposed to light*. The negative is removed and the exposed paper is *developed, washed,* and then placed in a *fixing bath*. Finally it is washed in running water to remove any remaining chemicals and then *dried*. The finished product is a *positive print* in which the *tone* and *colour* values appear as they were in the original object (white is white; black is black).

A Source of Light Is the Starting Point

Without light, there can be no photography. It's the light entering the camera that causes a change in the light-sensitive film to make a picture. All through the entire photographic process, light plays an important role.

In order to be able to make good pictures, it is important to understand what light is and how it is used in photography. Later you will learn how light can be controlled so that you will be able to take better pictures. You will also learn how light is used in the darkroom when developing film and making prints.

What Is Light?

Light is a form of energy explained by two theories, both supported by experiment. Some scientists describe it as a form of radiant energy transmitted from one point to another by electromagnetic vibrations or waves similar to the ripples that surround a stone thrown into a pond. In the 17th century, a Dutch physicist, Christian Huygens, performed many experiments that gave rise to the wave theory of light.

A second theory was proposed by the famous scientist, Isaac Newton, who lived at the same time as Huygens. Newton described light as streams of tiny, invisible particles which he called "photons." It was also discovered that

light rays (radiant energy or photons) travel at the almost unbelievable speed of 186,000 miles per second.

How Light Acts

It is important to remember that without light nothing can be seen and everything will appear black. Take this book into a room, turn off the lights—you will not be able to see the book. Turn on the lights and as the light becomes brighter, you will be able to see more of the book.

In order to understand how light acts so that we can see, there are several light terms that must be explained.

A *Luminous Body* is one that supplies its own light, light that is produced within itself. Examples of luminous objects are the sun, an electric light bulb, and a burning match.

An *Illuminated Body* is one made visible by light reflecting off it. Examples of illuminated objects are this book, the moon, a burned-out match, or any of the familiar objects that we associate with in our daily lives.

A *Transparent* medium is a substance which light can pass through freely and through which we can see either luminous or illuminated objects. Clear glass, cellophane, and air are examples of transparent substances.

A *Translucent* medium is a substance that offers resistance to light and causes it to scatter. Examples of translucent mediums are frosted glass, wax paper, and some plastics.

An *Opaque* medium is a substance that prevents any light from passing through. Examples are a brick wall, a piece of wood, and a sheet of thick cardboard.

To be able to take good pictures, it is essential to understand the above terms in order to know how light acts when exposing light-sensitive materials. Under certain conditions an object normally translucent will appear transparent. The thickness of a medium often determines how it will respond to light. Water that normally is transparent will appear translucent or even opaque when the volume is extremely great. Paper that is translucent can be made transparent by increasing the light intensity.

Another property of light is that *Light Always Travels in Straight Lines,* and mechanical methods must be used to change the direction of light rays.

EXPERIMENT
Light Travels in a Straight Line

INTRODUCTION: This is an experiment of observation of something we all do many times every day.

MATERIALS: As listed in WHAT TO DO.

WHAT TO DO: On a day when there is a way to see your footsteps as you walk (when there is snow on the ground, the roads are dusty, when the ground is sandy, etc.) find an object about 500 to 1000 feet away and keep on looking at it as you walk toward it. When you have reached the object, turn around and look at the tracks you have made. You will see that your steps have followed a straight line.

WHAT HAPPENS: As light travels from

a source to a point in the distance, the rays follow a straight line.

EXPERIMENT

More Proof That Light Travels in a Straight Line

MATERIALS: Four 5-inch squares of cardboard with a half-inch hole in the centre; candle.

WHAT TO DO: Fasten the squares of cardboard to wooden blocks so they will stand upright. Line them up in a straight line so you can look through all four of the holes at the same time. Light a candle and place it so the flame can be seen through all of the holes at the same time. The cards should be approximately 10 to 14 inches apart. Now move one of the cards a little out of line in relation to the others. Observe what happens when you try to look at the candle flame through the hole.

WHAT HAPPENS: We have already learned from the previous experiment that light travels in a straight line. This experiment is still further proof. Moving one of the cards from the path of vision shows that light rays will not bend to find the hole through which they can pass.

What Is Reflection?

It is important to understand what happens to light when it strikes a transparent, a translucent, or an opaque substance. The nature of the substance and its surface determine what will happen to the light rays.

When light rays strike an opaque substance, they bounce off to strike another object. This is *Reflection* and is the change in direction of light rays after striking an object. Imagine several parallel light rays striking a smooth, highly polished surface—they are reflected unchanged. They rebound parallel to each other, all in the same direction. This is called regular reflection. When a beam of parallel light rays strikes a rough surface, they bounce off reflected or scattered in all directions. This is called diffuse reflection. Almost everything that we see around us, we see by diffuse reflection.

Reflection can be a critical factor when taking pictures. Reflection of light from a highly polished surface can cause unwanted glare. Always be careful that your subject is not standing in front of a highly reflective surface when taking a picture.

EXPERIMENT

A Demonstration of Reflection

MATERIALS: A small rubber ball; square pocket mirror; small comb; a sheet of white cardboard.

WHAT TO DO: The first part of this experiment is a demonstration to show what reflection is.

Bounce the rubber ball onto the floor or wall by dropping or throwing it from positions that range from being perpendicular to angles of varying degrees. Try to note the angle at which the ball bounces off the floor or wall and compare it to the angle at which the ball was dropped.

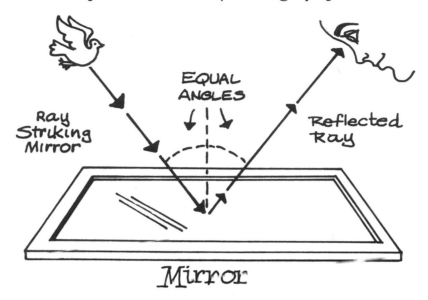

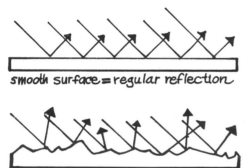

smooth surface = regular reflection

rough surface = diffused reflection

The second part of this experiment is replacing the ball with light to show that the same thing occurs when light is "bounced" off a shiny or smooth surface.

Have someone hold a comb perpendicular to a sheet of cardboard so that sunlight (or other bright light) passing through the teeth of the comb will make a pattern of light rays that are several inches long. Place a mirror in the path of these rays of light and observe what happens as they strike the shiny, reflective surface of the glass. Change the position of the mirror and observe what happens.

WHAT HAPPENS: Reread the explanation of reflection that preceded this experiment. Assume the rubber ball is a ray of light. As you changed the position from which the ball was dropped, the angle at which the ball bounced from the surface changed. The ball bouncing from the surface is reflection.

Changing rays of light (second part of the experiment) for the ball is further proof that reflection occurs when light strikes a surface and is bounced off to travel in another direction.

What Is Refraction?

What happens when light strikes a transparent material such as a glass of water or the lens in a camera? Depending upon the material, light rays pass through with varying degrees of resistance. Observation would reveal that there is a change in their direction.

This is *Refraction* and is the bending of light rays as they pass through different materials. This is the property that

lenses have that makes them important in photography. They are able to collect rays of light reflecting from the surfaces of different objects and bend them so they will travel in a straight line to form an image. Refraction can be explained as follows: As light rays travel, their speed changes as they pass through different materials. When there is a change in speed, there is a change in direction.

REFRACTION

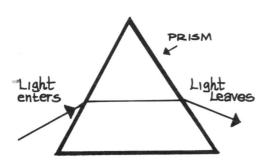

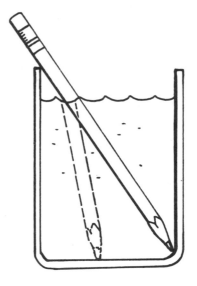

By careful design, it is possible to construct a lens that will change the direction of light rays that have been scattered by diffuse reflection so that they travel in a straight line and thus form an image of the object being photographed. This image is then recorded on the light-sensitive film inside the camera.

EXPERIMENT

A Demonstration of Refraction

MATERIALS: A wooden pencil; glass of water.

WHAT TO DO: Place the pencil in the glass of water, making certain that some of the pencil is above the surface. Observe the glass and pencil by looking through the side of the glass. Where the

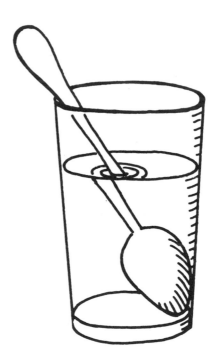

pencil enters the water, it appears to bend.

WHAT HAPPENS: We see the pencil by reflection because the rays of light bounce off. As the light rays pass through

the air, they travel faster as compared to their speed in the water. Because the water slows them down, the pencil appears to bend at the point where the light rays leave the air and enter the water. This bending is refraction.

EXPERIMENT

Refraction with a Lens

MATERIALS: Magnifying glass; sheet of white paper; torch, pencil.

WHAT TO DO: Support the torch to prevent it from being moved. The light should shine onto a sheet of paper. With the pencil, outline the area lighted by the torch.

Hold the magnifying glass in front of the torch and move it back and forth until the light from the torch is reduced in size as much as it can be. Outline the area of this circle with a pencil.

WHAT HAPPENS: Reread the explanation of What Is Refraction. From the previous experiment where we observed that light rays bend when they pass through different materials, the glass of the lens can be compared to the water. As the light rays pass through the glass they bend to form the smaller circle of light. You will also observe that this smaller circle of light appears much brighter than the larger.

What Are Lenses?

A camera has already been described as a light-proof box into which light rays enter to record an image on light-sensitive film. The light enters through a lens which can be found in an opening in one end of the box. The lens in a camera can be described as a transparent optical element constructed of either glass or plastic and having at least one curved surface. A lens collects light rays reflecting from the object being photographed and brings them into sharp focus by refraction.

Understanding focus often confuses the amateur photographer. This can be eliminated by remembering that focus is the property of lenses to form an image that appears exactly like the object being photographed.

A lens is in focus when the distance between the object and the lens is in direct proportion to the distance between the lens and the light-sensitive film. Changing one requires changing the other. By careful design, it is possible to make a lens in which everything past the point of four or five feet is in perfect focus. This is the type of lens used in the non-adjustable simple camera you will use in connection with this book. With this type of camera no adjustments are necessary since they have already been made by the manufacturer.

A lens focuses light rays by bending them so they will meet at a common point. The place where the light rays meet is known as the point of focus. At this point the image formed is exactly like the object and will fall on the film in position here. A picture of an image that is in front or in back of the point of focus will be blurred and not clear. In this case, photographers describe the picture as being out of focus.

All lenses are constructed from two basic shapes depending upon their use. When light strikes an object and reflects off it, the light rays tend to scatter in all directions. Lenses are used to collect scattered rays of light to form an image that is in focus. To understand how lenses do this, it is important to remember that as light passes from one medium to another it tends to change in direction or bend. As light rays pass through a lens they bend toward the thickest part, and at a certain distance beyond the lens they come together to form a point.

EXPERIMENT

Formation of a Picture Image by a Lens

MATERIALS: Hand lens (magnifying glass); sheet of white paper.

WHAT TO DO: This experiment will require the assistance of a second person. Darken all but one of the windows in a room. One person should hold the lens in front of the window while the other person slowly moves a sheet of white paper toward the lens. The lens should be between the paper and the window. When the paper is the correct distance from the lens, a picture (image) will be seen to appear on the paper.

WHAT HAPPENS: Reread the discussion about lenses that appears just before this experiment.

A lens that collects light rays and bends them so they meet at a common point past the lens to form an image is called a convex lens. Convex lenses are

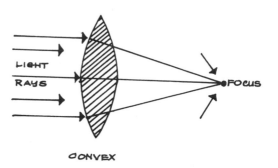

CONVEX

thicker in the middle than at the outer edges.

The second basic type of lens is the concave lens, which is thin in the middle with gradual thickening toward the outer edges. Light rays passing through the lens tend to scatter. A camera calls for the use of a convex lens rather

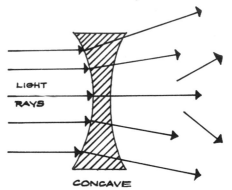

CONCAVE

than a concave lens. Combinations of different lenses designed for a specific purpose are referred to as a lens system in which each individual lens is referred to as an element. Lens systems often consist of both convex and concave lenses.

In any camera—simple or complex— the lens is the most important mechanical part. We have already learned that the lens collects the light rays and focuses them to form an image which is then projected onto the light-sensitive film. In a later experiment we will con-

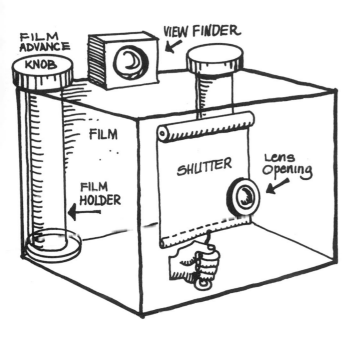

FILM ADVANCE KNOB

VIEW FINDER

FILM

FILM HOLDER

SHUTTER

Lens Opening

justed to control the length of time the light is allowed to enter the camera. It is important to remember that careful adjustment must be made to obtain the maximum capacity of a lens to take a good picture. In the simple box camera the lens, diaphragm, and shutter are usually non-adjustable. They are pre-set by the manufacturer, and adjustments are not necessary to obtain a good picture.

Always remember that a lens collects light rays with its entire surface and the larger the open area, the more light that will enter and, as photographers say, "the faster the lens." In cameras where lenses can be adjusted, the speed is often indicated by the f number system. The lower the f number, the larger the lens. For example, cameras with an f4.5 lens will have a much greater opening than the camera with a lens set at f16.

These numbers indicate the size of the diaphragm opening as a fraction of the distance between the lens and the film (the "focal length"). Thus f16 is an opening 1/16th of the focal length, and f8 is 1/8th of the focal length.

What Are the Parts of a Camera?

Most people think that cameras are complicated, difficult to operate, and that it requires special training to be able to use them. Some cameras have a few extra mechanical features that are used for specialized photography. However, *all* cameras are basic in construction and understanding how they work is not difficult. Manufacturers always include a manual of instructions with each camera. This should be read and reread before using your camera to take pictures.

struct a simple camera that will consist of nothing but a light-proof box, a lens, and a sheet of film. We will use this camera to take pictures.

Some lenses must be adjusted to obtain the maximum efficiency of the lens to collect enough light to be able to record a clearly defined picture. This is done by adjusting a mechanical device known as the diaphragm. The diaphragm makes the lens opening larger or smaller to control the amount of light allowed to enter the box. Where there is an adjustable diaphragm, there is usually a device known as the shutter that must be ad-

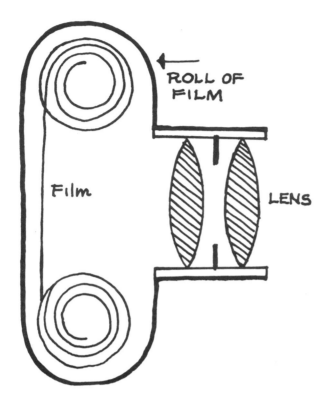

ROLL OF FILM

Film

LENS

Stripping the advanced camera of all its specialized refinements, there is left a light-proof box with simple devices that are used to focus and control the rays of light that enter to form a picture on the light-sensitive film. In brief, the essential parts of any camera are:

1 A *box* that has been made light-proof.

2 A *lens* that collects and focuses the light rays that reflect off the object being photographed and projects them onto the light-sensitive film.

3 The *diaphragm,* a mechanical device that can be opened or closed to control the amount of light that enters the light-proof box.

4 The *shutter,* a mechanical device that controls the length of time the light is allowed to enter the light-proof box.

5 The *viewfinder* that allows the object being photographed to be observed first. The viewfinder, on some cameras, is used to make certain that the picture is in focus. It is also used for composing the picture so the finished photograph will show exactly what was in focus before the shutter was opened and closed.

6 The *film holder* that keeps the light-sensitive film in correct position at all times.

7 A *film advancer* that allows the exposed film to be changed so that another picture may be taken. On some cameras a film counter is connected to the film advancer to show how much film is left.

Modern cameras have many labour-saving mechanical attachments designed for the particular type of camera being used. These have not been described because only the experienced photographer will use them, and this book was written to explain only the basic principles of photography to the beginner.

Different Kinds of Cameras

All cameras are basically similar in construction and differ only when their design has been adapted for a specific purpose. There are many different kinds of cameras, and the following are the most popular:

1 The *box* camera is the least complicated. It is a light-proof box with a fixed focus lens, a pre-set diaphragm, and a non-adjustable shutter. When using a box camera there is no need to

adjust anything—just aim and squeeze the shutter to take a picture.

2 The *folding* camera, which is similar to the box camera, has a bellows that will collapse so that the light-proof box will fold up for compactness. Folding cameras are two types: (a) with a fixed focus lens, a pre-set diaphragm, and a non-adjustable shutter; or (b) with a lens which can be focused, a diaphragm opening that can be made smaller or larger, and a shutter which can be changed to increase or decrease the speed of the opening.

3 The *miniature* camera is designed for ease in handling and uses film that makes small negatives which must be enlarged when making positive prints. Like the folding camera, the photographer may choose from two kinds—adjustable and non-adjustable.

4 The *reflex* camera has a ground-glass screen for viewing the object being photographed before taking the picture.

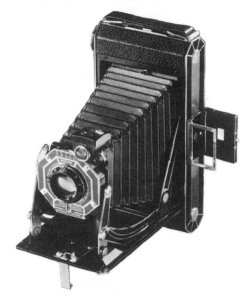

The Six-16 Kodak camera of 1932.

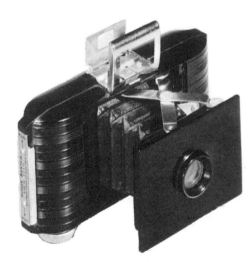

The Bantam, of 1935, was Kodak's first miniature camera.

There are many different kinds of reflex cameras, and a detailed description is beyond the scope of this book.

5 The *press* camera usually has the ground-glass screen of the reflex camera and the bellows of the folding camera. The press camera is much larger than any of the cameras already described

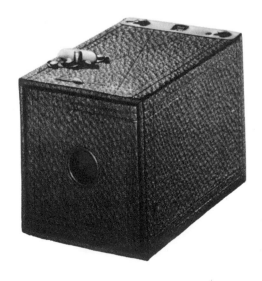

The dollar Brownie camera of 1900, designed for children, was soon being used by adults also.

and is completely adjustable. It was designed for press (newspaper and magazine) photography.

6 The *view* camera usually has the same features as the press camera, but is much larger in size. It was designed for the commercial photographer specializing in portrait photography.

7 The *stereo* camera was designed for three-dimensional photography. It has two lenses and takes two pictures—one of what the left eye sees, and the other of what the right eye sees. The two pictures are slightly different, and looking at these photographs through a special viewer creates a three-dimensional effect of depth.

8 The *ultra-miniature* camera, an invention of the war years, is not much larger than a pack of cigarettes and may even be as small as an ordinary fountain pen. This camera uses very small film and takes more pictures on a single roll of film than any of the cameras described.

9 The *polaroid-land* camera, brought to perfection in the last two decades, has an advantage over all other cameras. A finished positive print is developed within a few seconds after pressing the shutter. The chemicals for developing and printing are self-contained in the film and processing is automatic. Polaroid film is available in both black-and-white and colour.

EXPERIMENT

How a Camera Works

MATERIALS: Two boxes that will telescope over one another as tightly as possible and still slide apart without any difficulty; wax paper; small convex lens; black masking tape.

WHAT TO DO: The lens from an inexpensive (toy-like) magnifying glass will work. Measure the approximate distance between the lens and a sheet of paper when the image seen through the lens is in sharp focus. This should be the approximate length of the boxes less one inch. The width and height are not too important. Three to four inches square should prove adequate.

Remove one end from each of the boxes and slide one over the other with the open ends together. Next cut out the back end of one box, leaving at least one-fourth of an inch ridge for support. With masking tape, fasten wax paper over this cut-out section.

In the front end cut out a hole the size of the lens, and carefully fasten in place, using masking tape. Try to cover as little of the lens as possible.

In bright sunlight, aim the lens at an object and slide the boxes in and out until a sharp image appears on the wax paper.

WHAT HAPPENS: Reread the sections What Is Reflection, What Is Refraction, and What Are Lenses. In this simple camera, when a sharp image appears on the wax paper, the camera is in focus. The wax paper is where the film would be placed if light-sensitive materials were to be used instead. In another experiment, we will construct another simple camera which will be used to expose film to take a picture.

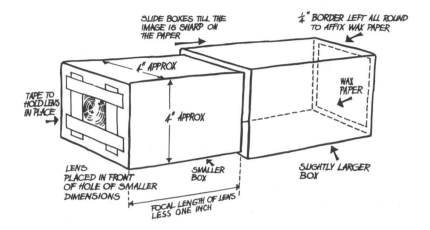

Why Is the Image Upside Down?

No matter what kind of camera is used —a simple pinhole, or the most complicated with a lens—unless the optical lens system has been set to correct the image that forms, it will appear upside down.

Light rays that reflect off the top of the object travel downward to pass through the pinhole or lens. As they enter the camera they continue downward while the light rays that reflect from the bottom of the object travel upward and the image that forms appears upside down.

What Is a Pinhole Camera?

There is little difference between the simple box-type camera we will use in many of the experiments in this book and a pinhole camera. In many ways they are the same with one major exception—instead of a lens, a pinhole camera has a very small hole through which the light rays enter to record an image on the film.

Known as the Camera Obscura, Latin for "dark chamber," the pinhole camera preceded the modern camera of today by several centuries. Simple in construction, it is a box made light-proof with

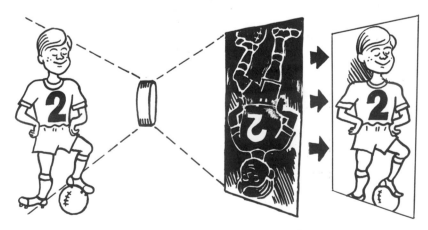

light-sensitive film at one end and a very small pinhole at the opposite end.

Why Use a Pinhole Camera?

A pinhole camera should not be thought of as an inferior, old-fashioned instrument. Many professional photographers still use pinhole cameras to take pictures that have great quality.

Taking pictures with a pinhole camera is the same as taking them with a modern camera of today. First, light-sensitive film is placed inside; second, the camera is aimed at the subject and the shutter opened to let the rays of light reflecting off the subject enter the camera and record an image onto the film; third, the shutter is closed.

Because the hole through which the light rays must pass is very small, the exposure time when taking a picture with a pinhole camera is much longer when compared to using a camera with a lens. This is relatively unimportant when considering the final results. Pictures taken with a pinhole camera are free from distortions caused by many lenses used in modern cameras.

With a pinhole camera there is no focusing problem. Everything the pinhole camera "sees" is in focus. Reread the explanation about Different Kinds of Cameras.

EXPERIMENT

How to Make a Pinhole Camera

MATERIALS: An empty box; aluminum foil; black paint; black masking tape; a No. 10 sewing needle; 2 sheets of white paper; heavy black cardboard; glue.

WHAT TO DO: The box should measure approximately six inches long and about five inches square and have a removable cover. Paint the inside black. Make the film holder by cutting two pieces of black cardboard the same size as the inside end of the box. From one piece of cardboard cut out a horseshoe-like opening $4\frac{1}{16}''$ x $5\frac{1}{8}''$. In the second piece cut out an opening $3\frac{5}{8}''$ x $4\frac{5}{8}''$. To assemble the film holder, the cardboard with the larger opening should be cemented inside the box first with the open end upward. Then cement onto this the piece with the smaller opening, open and upward. This makes a frame that will hold the film in place.

At the other end of the box, opposite the film holder, cut a hole in the centre one-half inch in diameter. Cut a piece of aluminum foil one inch square and lay it flat on a piece of cardboard. Using the needle, carefully push it through the foil to make a clean, smooth-edged hole. Do not make it too large. Using black masking tape, fasten the foil over the hole in the box with the foil on the inside. The pinhole should be in the exact centre.

A shutter to cover up the pinhole when not exposing the light-sensitive film can be made by fastening a cardboard flap on the outside of the box using masking tape to hold it in place.

Using black masking tape, seal all the edges and corners to prevent any possible light leaks. Do not seal the cover in place until after the next experiment

when you will use the camera to take pictures.

One more thing remains to be done. On top of the camera draw a line from the rear left and rear right corners to the centre of the front edge of the camera. These are viewfinder lines, and anything sighted within these lines will also be seen by the camera.

Why Is the Pinhole Size Important?

In addition to making certain that the box is light-tight, the size of the pinhole is very important.

If the pinhole is too small the light rays will strike the edges and diffract to cause a fuzzy-edged image to form. Making the pinhole too large will admit too many rays of light reflecting from the object being photographed and the picture will be blurred.

How Long Must Film Be Exposed?

When film was first invented it was necessary to expose it for several minutes to record an image. The discovery of new chemical compounds has made it possible to construct light-sensitive film that requires only a fraction of a second to make an exposure. Another factor that has made this short exposure to light possible is the use of lenses that are capable of admitting more light in a shorter length of time.

In the pinhole camera the lens has been replaced by a pinhole that is so small it often takes several seconds of

exposure to let in enough light to take a picture. In bright sunlight, using film with an American Standard Association (ASA) rating (daylight speed) of 100 to 125, (to be explained later) exposure should be about ten seconds. If you use film with a speed rating of 50 to 64, increase the exposure time to twenty seconds, etc. It might be necessary to experiment to determine the correct exposure. Therefore, take several pictures of the same object increasing and decreasing the exposure time by a few seconds. Have handy a notebook to jot down (for future use) the conditions under which the picture was taken and how long you exposed the film. This will help you when taking pictures another time.

Don't forget to change the exposed film for unexposed film each time you take a picture. Since pinhole cameras cost only pence, you might take two or three cameras to save time having to change film. Keep the exposed film in a sealed, light-tight box until it has been developed.

EXPERIMENT
How to Take a Picture with a Pinhole Camera

MATERIALS: Pinhole camera; Verichrome-Pan sheet film; black masking tape.

WHAT TO DO: In a darkroom slide a sheet of film (emulsion side towards the pinhole) into the film holder. Place the cover on the box and seal with tape to prevent light leaks that might ruin the film. Make certain the shutter is closed.

Take the camera outside and place it on a flat surface, pointing the pinhole towards the object you want to photograph. Use the viewfinder to aim the camera. To prevent the camera from moving while taking the picture (any movement will spoil the picture) place a heavy object on top of the camera.

Open the shutter and expose the film to take a picture. After exposing the film, close the shutter and take the camera back into the darkroom. Remove the film and place it in a light-proof box until you have it developed. While in the darkroom you can reload the camera with more film.

A FEW REMARKS: The pinhole replaces many of the mechanical features of the modern camera. The pinhole not only acts as a lens, but also controls the amount of light that enters the camera. If the opening is too large, too much light might enter. This could result in a blurred picture or the lack of control in deciding the correct exposure time. It is important that the pinhole is made as explained in a previous experiment.

Also consider the brightness of the light. On a bright day the exposure will not have to be as long as one made on a cloudy day. Experiment will also reveal that the farther the film is from the pinhole, the longer the exposure time. In constructing your pinhole camera, try to use a box as described in the experiment.

Taking these three factors into consideration: (1) the size of the pinhole; (2) the amount of light available; and (3) the distance of the pinhole from the film, you will have to experiment with different exposure times. Always remember to keep accurate records for future reference.

Finally, remember that accidental exposure of film to light will ruin it. Always load and unload your camera in a darkroom and keep exposed film in a light-proof box until you have it developed.

Having the Exposed Film Developed

This step is the answer to a question you might ask: "What kinds of pictures did I take and will they come out?" If you have constructed your pinhole camera correctly and have used it as explained in the previous experiment, it is a fool-proof device and you should get satisfactory pictures.

To find out, you will have to get the film developed and since developing is not explained until later, it will be necessary at this point to have someone else do the developing. Take the exposed film, still in the tightly closed box, to a store that develops film. Be sure to say what kind of film you used and how it was used.

The exposed film will be sent to a photographic laboratory where it will be processed, and the finished negatives will be returned to you. If you want, you can also request that prints (positive pictures) be made. Examination of the negatives and prints will reveal any errors.

light-sensitive materials

An Introduction to Film

The most important part of any camera is the person who presses the shutter. Knowing how to use your camera with the correct kind of film is what guarantees that the film will "capture" the picture you wanted.

In order to take good pictures it is important to learn about film—what it is and how it works. There are many kinds of film, each intended for a specific use. Knowing when and how to use them is a step toward being able to take better pictures. This section is limited to the discussion of black-and-white film.

How Film Is Manufactured

There are three major steps in the manufacture of film. These are: (1) the preparation of the emulsion from light-sensitive silver compounds and gelatin; (2) the manufacture of the film base; and (3) coating the base with the emulsion.

For the first step in the manufacture of film, metallic silver is allowed to react with nitric acid to form silver nitrate. Gelatin is dissolved in warm water to make a syrupy solution to which is added the silver nitrate along with potassium bromide and potassium iodide. The mixture is kept moderately warm to allow the emulsion of silver bromide-silver iodide to "ripen." It is then allowed to cool slowly as further gelatin is added. The mixture is allowed to set and then shredded into fibres and washed with water to remove any excess potassium bromide or iodide.

The film base is prepared by first treating cellulose (cotton fibres or wood pulp) with acetic acid. The resulting cellulose acetate is dissolved in solvents to make a clear, syrup-like fluid known as "dope." The dope is then made to flow evenly onto heated rollers which drives off the solvent, thereby leaving a thin, flexible transparent sheet of plastic.

The emulsion is warmed to form a thick, syrup-like solution which is used to coat the film base. This is cooled very slowly. Applied to the back of the film are special dyes (their use to be explained later) known as the antihalation backing. On top of the light-sensitive emulsion a clear coat of gelatin is placed. The film is then cut to size, packed, and stored in temperature-controlled rooms until it is sent out to shops for sale.

This is a very brief description of the manufacture of film. There are many refinements and improvements in the chemicals and materials used.

PROTECTIVE TOP COAT

light-sensitive emulsion

PLASTIC FILM BASE

ANTIHILATION BACKING

The Structure of Film

If it were possible to examine a cross-section sample of a modern black-and-white film, we would see that it is composed of four layers: (a) the *top coat,* a clear gelatin coating used to prevent surface abrasions on (b) the *emulsion,* the light-sensitive silver salts held in place by gelatin; (c) the *film base* made of clear plastic which is coated on the underside with (d) the *antihalation backing.* This backing prevents light which passes through the film from bouncing back and causing secondary or ghost-like images. The antihalation backing and the protective top coat are removed during developing.

What Is Film Sensitivity?

Taking a picture requires the use of light-sensitive materials known as film. Different films vary in their sensitivity to light. For example, Kodak Verichrome Pan medium speed (125 ASA) is less sensitive to light than Kodak Tri-X or Ilford HP4 (400 ASA), and requires a larger amount of light to produce a pic-

ture. If you were to use Verichrome Pan under the same conditions as you would Kodak Tri-X, it would be necessary to have a camera that can be adjusted to have a larger lens opening or a longer shutter time. The simple box-type camera that we will use in later experiments has been designed to use Verichrome Pan film and unless your camera is adjustable you should not use anything faster.

To increase the sensitivity of film to light, manufacturers use special dyes added to the emulsion. As a measure of sensitivity, the American Standards Association in 1943 established numerical ratings which referred to film speeds by a series of numbers. The numbers were designated as ASA ratings and the higher the numerical ASA rating the faster the film and the less light needed for making an exposure.

Different Films and Their Use

There are many brands of film on the market. As examples of the many types of films that a photographer can choose from, those manufactured by Kodak have been selected. However, any dealer

in photographic supplies will recommend films of other manufacturers upon request.

VERICHROME PAN is an all-purpose black-and-white film for daylight and flash (we will discuss this later) picture-taking in both box and adjustable cameras.

PLUS-X is a general purpose, average speed, black-and-white film, and available for use in 35 mm. cameras only.

TRI-X is a very fast light-sensitive film which is more than three times as fast as Verichrome Pan and Plus-X, and is used for taking black-and-white pictures when the light is very dim. It must not be used in non-adjustable cameras because of the possibility of overexposure resulting.

PANATOMIC-X is a black-and-white film that is less sensitive to light than Verichrome Pan and requires greater exposure. It must be used only in adjustable cameras and is generally used for specialized picture-taking.

What Is Film Latitude?

Cameras must be set for the film being used and the conditions prevailing when the picture is taken. Since a box camera is pre-set by the manufacturer, the question often arises as to why, when the light conditions vary, the pictures are exposed correctly without having to make any adjustments.

This is due to a property of film that photographers refer to as "latitude." Latitude is the range in which film will record an acceptable picture when it is exposed to more or less light than it has

been designed for. Different films vary in the amount of latitude they possess.

Let's Look at a Roll of Film

Film comes in a sealed, moisture-proof, light-proof bag. This is packaged in a cardboard box that has printed on it the kind of film (Verichrome Pan, Plus-X, etc.), the size, and the date by which the film must be used. Never purchase film if the box or bag has been opened or the date has expired.

Removing the film from the bag, you will find a plastic or metal spool on which there is a roll of heavy paper. This is the protective backing paper. You should be able to get backing paper from an amateur photographer, or by writing to a large trade dealer, as it is of no value once the film has been developed.

Why Is the Backing Paper Important?

Using Kodak backing paper as an example, the inner side that faces the film is black. The beginning of the film is attached to this side with tape. At the other end the film is not attached to the backing paper. The edge of the paper is slightly wider than the film and makes a light-tight seal to prevent accidental exposure to light.

Turning the paper over and starting with the beginning, which is shaped to fit a slot in the film spool, you will see that the other side is yellow and there is printed on it much important information.

At the beginning of some makes of film there are narrow bands of different colours that are used to identify the kind

of film (red for Verichrome Pan, green for Tri-X, etc.). These narrow bands of colour also serve to remind us that the film has not been exposed. At the other end the colour appears across the full width of the backing paper to show that the film has been exposed. At this end there is also a piece of gummed paper to be used for sealing the exposed roll of film.

At the beginning we find printed information for some films such as Verichrome Pan. This information explains how, where, and when the film should be used. Following this, several arrows appear to signal that the first exposure is near.

In one camera a roll of film may be used to make eight pictures. In another, the same roll may take twelve or more pictures. In order that the same film can be used in different cameras, examination of the backing paper will reveal two or more rows of numbers that are equally spaced along the length of the paper. These are the exposure numbers that appear in the red window on the back of the camera when the film is in correct position for taking a picture. The location of the red window is positioned so the correct series of numbers will be visible. The film name precedes each number to remind the photographer what kind of film is in the camera.

There Are Other Light-Sensitive Materials

Thus far we have learned about light-sensitive film. In photography there are many other light-sensitive materials. To make positive prints from negatives, printing paper is used. This is similar to film with the exception that instead of plastic, ordinary paper is used, on which is coated the light-sensitive silver compounds. There are many different kinds of printing paper which we will learn about later.

Other light-sensitive materials include blueprint paper, which is constructed of light-sensitive chemicals different from those used in photographic film and paper. The developing process is also different and uses ordinary water to make the picture appear.

Blueprint paper goes back to 1842 when it was observed that ordinary sunlight was capable of causing permanent changes to occur in certain chemical compounds. Research has provided many other chemicals that can be used, and today science has developed a light-sensitive paper coated with solutions of ferric ammonium citrate and potassium ferricyanide. This combination of chemicals is sensitive to many different kinds of light and when coated on paper it can be used to make copies of documents and drawings.

In 1920, another process was invented known as the Whiteprint Process. It is based on the discovery that certain chemicals are sensitive to ultraviolet light and can be developed by exposure to ammonia vapours or liquid.

EXPERIMENT
Preparation of Blueprint Paper

MATERIALS: Potassium ferricyanide; green ferric ammonium citrate; water; white typewriter paper; paper towels; covered box.

WHAT TO DO: In a semi-darkened room dissolve 1 tablespoonful of potassium ferricyanide in 2 ounces of water. Prepare a second solution by dissolving 1 tablespoonful of ferric ammonium citrate in 2 ounces of water. Pour both of these solutions into a glass dish.

Cut several pieces of paper six inches square and carefully draw them, one at a time, across the surface of the solution several times, making certain that only one side is coated with the chemicals. Place the treated papers, chemical side up, on a sheet of absorbent paper toweling and let dry. When dry, the blueprint paper should be kept in a covered box to prevent accidental exposure to light.

EXPERIMENT

How to Make a Blueprint

MATERIALS: Blueprint paper (from previous experiment); water.

WHAT TO DO: Place a pencil, coin, key, or a photographic negative on a sheet of blueprint paper. Expose the paper to bright sunlight for 3 to 5 minutes. (Some experimenting might be necessary to determine the correct exposure.) Wash the exposed paper in water until a picture appears. Press the print dry between paper towels and place a heavy book on top so it will dry flat.

Note: When using a tracing or photographic negative it is necessary to hold it in place with a sheet of glass. Be sure that the glass has been washed clean and dried before using.

WHAT HAPPENS: When solutions of ferric ammonium citrate and potassium ferricyanide are mixed together, the result is a light-brown, complex light-sensitive solution. When paper that has been coated with this solution is exposed to light, the fer*ric* ammonium citrate changes to fer*rous* ammonium citrate. This reacts with the potassium ferricyanide to form insoluble, non-sensitive ferrous ferricyanide (Turnbull's blue). Where the paper has not been exposed to light there is no change and the mixture of unchanged iron compounds is washed away by the water. This leaves the permanent blue ferrous ferricyanide and a white picture.

EXPERIMENT

How to Make Light-Sensitive Photographic Plates

IMPORTANT: *This experiment must be done in a semi-darkened room, or in a room illuminated by a safelight (red bulb).*

MATERIALS: Potassium bromide; silver nitrate; several sheets of thin glass about 3 inches by 5 inches; soapless detergent; distilled water; gelatin; black construction paper; aluminium foil; plastic measuring spoons; filter paper; paper towels; plastic funnel.

WHAT TO DO: This is a two-part experiment in which you will first prepare light-sensitive silver bromide and then use it in the second part to make light-sensitive photographic plates.

Preparation of Silver Bromide Dissolve three-fourths teaspoonful potassium bromide in one-half cup of water. Prepare a second solution by dissolving

one teaspoonful silver nitrate in one-half cup of water. Mix the two solutions and separate the precipitate of silver bromide, that forms from the mixture, using filter paper and a funnel. Wash the silver bromide several times by pouring fresh portions of distilled water onto the precipitate. Allow to dry and remove by scraping with a plastic spoon. *Until ready to use, silver bromide must be kept in a dark, well-stoppered bottle.*

Preparation of the Light-Sensitive Photographic Plates

Using detergent, wash several sheets of glass and rinse clean. Ordinary tap water can be used. Dry by standing on edge on paper towels. Always handle the glass plates by the edges because fingerprints are oily and will spoil the finished photographic plates.

Dissolve two-thirds of a packet of gelatin in one-half cup of distilled water. Heat to boiling another cup of distilled water and add the gelatin solution. Continue heating for one more minute. Let the gelatin solution cool slightly and add the silver bromide from the first part of this experiment. *Remember— when you work with silver bromide the room must be semi-darkened or lit by a red bulb.* Continue stirring until the gelatin-bromide solution begins to thicken but is still liquid enough to pour.

Holding a sheet of glass by the edges, carefully pour one teaspoonful of the gelatin-bromide solution onto the surface. Gently tip the glass back and forth to coat the entire surface. It might be necessary to increase the amount of gelatin-bromide. Prepare several plates in

this manner and let dry. When dry, wrap each in a separate sheet of black paper and then in a sheet of aluminium foil. Place the plates in a box with a tight-fitting cover to prevent accidental exposure to light.

WHAT HAPPENS: Mixing silver nitrate and potassium bromide forms insoluble, light-sensitive silver bromide which settles out as a white precipitate. The remaining potassium nitrate that forms is soluble and is removed by filtering and washing.

Silver bromide will not adhere to the glass plates unless an inert substance such as gelatin is used to hold it in place. These plates are similar to those prepared by Dr. Maddox in 1871.

Many compounds of silver (silver nitrate, silver bromide, etc.) are sensitive to light, and when working with these compounds it is important that the room be darkened or illuminated only by a red light.

EXPERIMENT

How to Make a Photographic Negative

MATERIALS: Light-sensitive plates from the previous experiment; hydroquinone (or pyrogallic acid); sodium thiosulphate; water; torch; tracing; glass dishes (or photographic trays); measuring cup; plastic measuring spoons; sheet of glass 4 inches by 6 inches.

WHAT TO DO: Fasten a torch with the bulb downward so that it hangs 12 to 14 inches above your work area. Prepare 3 dishes as follows:

1 6 ounces of water and 2 teaspoonfuls of hydroquinone (or pyrogallic acid).

2 6 ounces of water.

3 6 ounces of water and 3 teaspoonfuls of sodium thiosulphate.

Darken the room as in the previous experiment and take one of the light-sensitive plates from the box. Remove the protective wrappings and with the emulsion side upwards, place a tracing on it. Hold it in place by covering with a sheet of glass. Turn on the torch and expose the light-sensitive plate and tracing for 2 minutes. Use a clock to check the time. Turn off the torch, remove the glass and tracing, and place the exposed plate in the first dish (hydroquinone or pyrogallic acid) for 2 minutes. Remove the plate and rinse for several seconds in the water in the second dish.

Next, place the photographic plate in the thiosulphate in the third dish, leaving it there for 2 to 3 minutes. Finally remove the plate from the dish and wash it for several minutes in a slow stream of running water. Do not let the water strike the plate too hard or the emulsion might be damaged. Turn on the lights and examine the developed plate. A negative picture of the tracing will be seen.

It might be necessary to experiment with the length of exposure time as different thicknesses of the gelatin-bromide mixture will require more or less exposure. Change the solutions in the dishes after the third or fourth plate has been developed.

WHAT HAPPENS: The light from the torch changes the silver bromide to an invisible metallic silver image. The image remains invisible until treated with the developer in the first dish. The developer changes the exposed silver bromide to visible metallic silver. The water in the second dish washes off the developer. The sodium thiosulphate (hypo) in the third dish dissolves any unexposed silver bromide that remains. Washing in running water to remove all chemicals after fixing is necessary to prevent the negative from fading or staining.

After fixing in hypo the negative is no longer sensitive and can be exposed to light without danger of being spoiled. Save the finished negative for a future experiment.

What Is Photographic Printing Paper?

Photographic printing paper is paper that has been made light-sensitive by coating it with the same chemicals used in the preparation of light-sensitive photographic plates.

To make a positive picture, a negative is placed in contact with a sheet of printing paper, exposed to light, and then developed using the same solutions as when developing photographic plates.

Are There Different Kinds of Printing Paper?

It's a good idea to make positive prints of every picture you take, as an aid to choosing the negatives you want to save. Most of the pictures you take will present no problems when making prints.

However, there are times when a negative might be overexposed or underexposed and to produce a "good" print, paper that has been designed for correcting bad exposures must be used.

There are also papers used for enlarging. These differ chemically slightly from those used for making contact prints. Positive prints can be made on paper designed to produce a glossy surface, or if a dull (matt) finish is desired, then another type of paper is used. There are papers with different thicknesses and one can choose from single weight or double weight for heavier prints.

These are only a few of the many kinds of photographic printing paper. There are many more, each designed for a special purpose.

EXPERIMENT

How to Make Photographic Printing Paper

MATERIALS: Silver nitrate; sodium chloride (ordinary table salt); sheets of unsized paper (paper that has not been coated with any surface-improving chemicals); distilled water; print tongs; measuring cup; plastic measuring spoons; glass dishes.

WHAT TO DO: Silver nitrate will cause stains, therefore use tongs to handle the papers when treating them with chemicals.

Dissolve 1 teaspoonful of silver nitrate in 8 ounces of water. Prepare a second solution by dissolving 1 teaspoonful of sodium chloride in 8 ounces of water.

Soak several sheets of paper in the sodium chloride for at least 2 minutes. Using tongs to hold the papers by the edge, remove them and place in the silver nitrate solution for 5 minutes. This experiment must be done in a semi-darkened room or in a room illuminated only by a red safety lamp. Remove the papers from the silver nitrate and let dry. Place the dried papers in a box with a tight-fitting cover to prevent accidental exposure to light.

WHAT HAPPENS: Silver nitrate is light-sensitive. By mixing sodium chloride and silver nitrate, another compound, silver chloride, which is much more sensitive to light, is formed.

EXPERIMENT

How to Make Photographic Positives (Prints)

MATERIALS: The photographic negative from a previous experiment; the photographic paper from the previous experiment; hydroquinone (or pyrogallic acid); sodium thiosulphate; water; torch; glass dishes (or photographic trays); measuring cup; plastic measuring spoons; tongs; sheet of glass 4 inches by 6 inches; film clips.

WHAT TO DO: Prepare the same solutions used in the experiment, "How To Make A Photographic Negative." Next, place together a sheet of the light-sensitive printing paper and a negative. Make certain that the emulsion side of the negative is in contact with the paper. Place both onto a flat surface with the paper on the bottom and cover with a sheet of glass to hold them together.

Turn on the flashlight, which should be suspended in a vertical position about 12 inches above the negative and paper. Expose the negative and paper for 2 or 3 minutes and then turn off the torch.

Remove the glass and negative, and place the paper in the developer (hydroquinone or pyrogallic acid) keeping it in there until a "good" picture appears. If the picture develops too fast add more water to the developer. If too slow, increase the strength of the developer by adding more of the chemical. If after 3 to 4 minutes a satisfactory picture does not appear, increase the time of exposure to the light. Some experimenting might be necessary because of the differences in thickness of the gelatin coating of the negative and the amount of silver chloride on the paper.

After developing, continue the chemical treatment by rinsing in water, fixing in the sodium thiosulphate (hypo), and then washing in running water to remove any chemicals that remain. Remove the prints from the final washing, let them drain, and hang up to dry, using film clips. When dry they can be flattened by placing under a heavy book for a few hours.

WHAT HAPPENS: The picture on the negative is transferred to the light-sensitive printing paper by exposing to light. The amount of light that passes through the negative is controlled by the thickness of the metallic silver. This produces an invisible image on the paper in which the light areas on the negative become the dark areas, and the dark areas become light. When developed and fixed, the invisible image becomes visible metallic silver with the final result a picture in which the subject appears as it originally was. Another name for photographic prints is positives.

EXPERIMENT
What a Negative Looks Like

MATERIALS: The same as the previous experiment with the following difference—instead of the photographic negative, you will need a black-and-white positive transparency.

WHAT TO DO: Repeat the previous experiment exposing the transparency onto the light-sensitive printing paper. Develop and fix the exposed paper as in the last experiment.

WHAT HAPPENS: Reread the previous experiment.

EXPERIMENT
Making Sun Pictures

MATERIALS: Photographic printing paper of a previous experiment; photographic negative or tracing paper design; sheet of glass 4 inches by 6 inches.

WHAT TO DO: Place together a sheet of photographic printing paper and a negative or tracing. Cover with a sheet of glass to hold them in place and turn on the lights. Continue the exposure until the paper turns dark-brown to blackish-violet. Turn off the lights and remove the glass and negative. Examine the print—you will see a positive picture.

WHAT HAPPENS: This is a simplified version of the experiment performed in 1802 by Thomas Wedgwood and Sir Humphry Davy. Exposure of certain silver compounds to light will change them to metallic silver. Save this picture for the next experiment.

EXPERIMENT

Exposing Sun Pictures to Light

MATERIALS: The sun picture of the previous experiment.

WHAT TO DO: Turn on the lights and continue to expose the sun picture to more light.

WHAT HAPPENS: The entire surface of the paper turns dark. Unless further treatment is rendered to the picture, it cannot be saved. It is suggested that you reread the section about Wedgwood and Davy.

EXPERIMENT

Making Sun Pictures Permanent

MATERIALS: Fresh sun picture; sodium thiosulphate (hypo); water; glass dish; plastic measuring spoons.

WHAT TO DO: Dissolve 2 teaspoonfuls of sodium thiosulphate in 3 ounces of water. Place the sun picture in this solution and treat for five minutes. Remove and wash in running water for several minutes.

WHAT HAPPENS: This is a demonstration of the discovery made by Sir John Herschel in the 19th century.

Sodium thiosulphate dissolves away any remaining silver compounds that might be affected by light. This leaves the metallic silver which appears as the picture. Metallic silver does not change when exposed to light and this is why the picture is now permanent.

taking your first picture

A Review—Introducing the Simple Camera

A camera is a box made light-tight with a lens in an opening at one end and film (light-sensitive material) at the other end. To prevent light from exposing the film until a picture is taken, a shutter is placed in front or behind the lens. The shutter opens and closes when a release is pressed. There is a winding knob to change the film after taking a picture and a window that lets you count the number of exposures made. There is also a viewing device that lets you see what the picture will include. Many simple cameras also have a flash unit (to be discussed later) for taking pictures in dim light.

What Is the Best Kind of Camera for the Beginner?

For a beginner who doesn't want to be an expert, but just wants to take pictures, the box-type camera is the simplest and least expensive. In simple cameras the lens, shutter, and focusing are usually pre-set by the manufacturer for taking pictures outdoors under a variety of lighting conditions, or indoors with flashbulbs. These cameras will not make pictures that have perfect professional quality, but will produce pictures that are very satisfactory.

Few beginners know that the simple camera can be used to take pictures normally thought impossible unless an expensive, very technical camera was used. Later we will learn how a simple box-type camera can be used for "advanced" photography.

Are There Different Kinds of Box Cameras?

It is possible to buy a box camera that has a simple lens diaphragm that can be adjusted to open or close the lens to compensate for existing light conditions. These adjustments are usually made for bright or cloudy days and when color film is being used. Still another adjustment is one that corrects for near and far distances. All other settings are usually pre-set by the manufacturer.

Simple cameras with these adjustments are inexpensive and not difficult to operate. The instruction manual that comes with the camera explains how to use these adjustments.

Finally, there are cameras where no adjustments of any kind have to be made. Simple to operate, they will make excellent pictures when used correctly.

Why Is it Important to Keep Camera Lenses Clean?

There are two reasons. First, lenses covered with dirt and smudges make fuzzy pictures. A clean lens will always make sharper pictures with better contrast. Second, dirt has a gritty effect that can cause scratches, and fingermarks can etch their way into the surfaces of lenses and ruin them.

The Correct Way to Clean Cameras and Lenses

Cameras are precision instruments built for carefree usage. When taken care of and given the right kind of maintenance, they can produce excellent pictures for many years. If for some reason your camera fails to work, don't try to repair it yourself. Take it to a camera repairman.

Always clean the front surface of your camera lens before taking pictures. Using lens tissues and a camel hair brush, gently wipe to remove lint and dust particles. Never use eyeglass cleaning tissues. They are chemically treated and are liable to damage camera lenses.

While at the shop buy a bottle of lens cleaning fluid. This is the only safe liquid to use when cleaning lenses that have hard-to-remove smudges such as fingerprints. Do not use facial tissues, they are not dust-free and are liable to cause scratches.

Finally—*never* attempt to take apart a camera to clean the inside surface of a lens. It doesn't get dirty. If the inside of a camera needs cleaning, it needs a trained repairman!

Follow the Instructions in Your Camera Manual

In order to know your camera and how to operate it, it's important that you read the instruction manual that comes with it. Camera instruction manuals contain a wealth of information. Spending a few minutes reading is time well spent and will help to prevent costly mistakes. As soon as you are familiar with your camera, load it with film and start taking pictures.

The Shutter

Shutters are mechanical "doors" that open momentarily to allow light inside the camera. In the simple camera the shutter is a series of movable, overlapping metal fins. In more advanced cameras some shutters are similar to a window blind having different size openings that travel across the surface of the film. In any camera, the purpose of the shutter is to open and close in a precise length of time to let in a certain amount of light. However, the shutter in the simple box camera is usually pre-set by the manufacturer to remain open for about 1/50 of a second. This is adequate for most picture taking under normal lighting conditions.

Some subjects are often too dark for snapshots, and time exposures must be taken. Examination of some cameras will reveal an adjustment marked "B," "Bulb," "Time," or "Long." When used, this adjustment allows the shutter to remain open as long as the shutter release is pressed down. "B," "Bulb," etc. settings are used for taking time

exposures when there isn't enough light. When taking time exposures the camera must be mounted on a tripod or held in a non-movable position. These settings should never be used when taking ordinary daylight or flash pictures. For your particular type of camera, the instruction manual will explain more about time exposures.

Those Mysterious Numbers and Letters

Box cameras, with a simple lens and a pre-set aperture (lens opening) and a pre-set shutter speed, are the easiest cameras to use. They are almost foolproof to operate and take excellent pictures under average conditions. The shutter speed in most box cameras is set at approximately 1/50 second and an aperture of f11 to f16.

Some simple cameras permit minor adjustments to be made to compensate for existing light conditions. The instruction manual that comes with your camera will explain how to make these adjustments.

However, there are cameras that have shutters that must be adjusted. These usually have different speeds that appear as a series of numbers. All the numbers on the shutter control represent fractions of a second. For example, 30 is 1/30 second, 60 is 1/60 second, etc. The higher the number, the shorter the shutter time. The subject being photographed and how fast it is moving determine at what speed the shutter must be set.

When using films that have different ASA ratings (film speeds) the lens opening must also be adjusted to admit the correct amount of light. Lens openings appear as f numbers which indicate the size of the opening through which light can pass. The smaller numbers indicate a larger opening.

Some cameras have lenses that must be adjusted for distance so the image formed will be in focus. On the front of the camera there is a series of numbers to show how far the subject is from the camera and at what distance the lens must be set.

The simple camera with the non-adjustable shutter sometimes has settings for lens aperture and distance. The aperture is usually adjusted for cloudy days, bright days, or colour film. The other adjustment is for near or far so that the cameras will be in focus.

What Kind of Film Does a Simple Camera Use?

The most popular films used today when taking black-and-white pictures are Kodak Verichrome Pan, Ilford FP4 and Boots Panchromatic. They are medium speed, general-purpose films having a wide exposure latitude and can be used under many different lighting conditions.

Colour pictures can be made using Kodacolor film. Developing this film produces a colour negative from which colour prints can be made. To make colour slides for projection use, Kodak Ektachrome Daylight Type can be used. For indoor colour photography, Ektachrome Indoor Type film with clear flashbulbs should be used or Daylight Type films with blue flashbulbs.

How to Handle Film

→Putting Film in the Camera

1 Always read the instruction booklet that comes with the camera. In most instances there are five steps to loading a camera with film. (a) Release the catch to open the back of the camera. (b) Place the roll of film between the spring rollers. At the other end there should be an empty spool between similar spring holders. This spool is attached to the winding knob. (c) Break the paper seal and holding the roll firmly to keep it from unwinding too far, carefully pull the backing paper until you reach the empty take-up spool. (d) Insert the pointed end of the backing paper into the slot in the spool. Turn the winding knob slightly to be certain the spool has taken hold of the film. (e) Finally replace the back, lock the camera, and wind the film slowly until the number "1" appears in the red window. You are now ready to take your first picture.

2 Never load a camera in bright light. Try to do it in a semi-darkened room or turn your body so the camera and film are shielded from bright light.

3 After taking the last picture always wind the film completely onto the take-up spool before opening the camera to remove the exposed film.

4 If your camera does not have a built-in mechanism to prevent double exposures, always turn to the next number immediately after taking a picture. Forgetting to do this is liable to result in two pictures on the same film, more commonly referred to as a double exposure.

5 When removing exposed film, do it in dim light as in (2) above. Upon removal fold the pointed end of the backing paper under and seal the roll with the gummed seal. Do not throw away the empty spool: you will need it to take up your next film.

→Taking Care of Film

1 Film does not improve with age. This is why the box in which the film is packaged has an expiration date printed on it. Never purchase expired (out-dated) film.

2 Film should always be exposed and developed before this date expires.

3 Heat and moisture can spoil film. Never keep film in warm places or where it is damp and wet.

4 Always keep film and cameras away from direct sunlight. When in a car, never put film and cameras in the glove compartment or on the rear ledge.

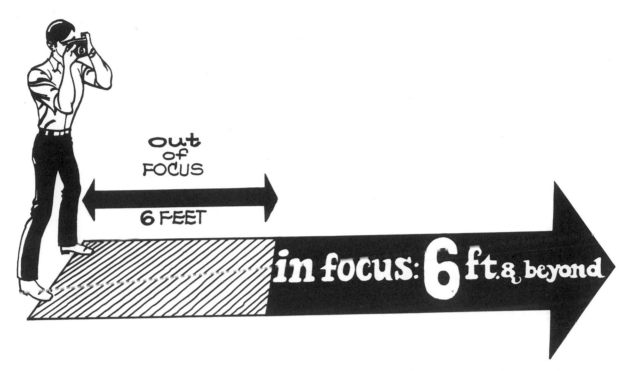

5 Always use up film in a camera and have it developed as soon as possible. Exposed film that is allowed to remain in a camera will age and spoil.

Focusing for Sharp Pictures

Beginners will find that simple cameras are usually pre-focused at the factory so that sharp pictures can be made of subjects that are 6 feet or more from the lens. Subjects closer than 6 feet will be out of focus. In comparison to pictures made by a camera that must be adjusted, those made by a simple camera have average sharpness and are usually very good.

Manufacturers have designed auxiliary lenses that can be used to take pictures of subjects closer than 6 feet. Known as close-up lenses, they are very simple to use. They fit over the regular lens and enable cameras to be used for taking pictures of subjects as close as twelve inches.

Camera Habits

Have you ever watched an experienced photographer at work? His experience has taught him "know-how" that has created habits that are important to guarantee success when taking pictures.

Establish a standard procedure when taking pictures. Don't use your camera until you have read the manual that comes with it. It contains important information that explains how an inexpensive camera can be used so that it will have more picture-taking versatility than you realized.

A few reminders—you will probably think of others—are:

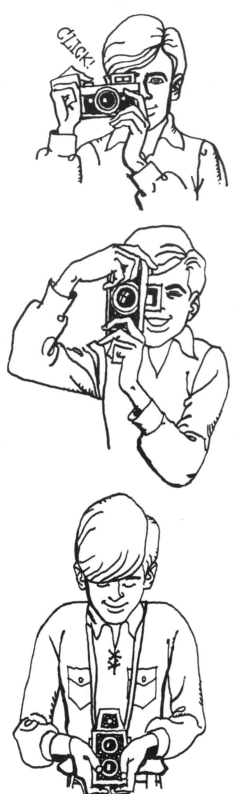

1 Avoid bright light when handling film. Load and unload in dim light only.

2 If there are any adjustments on your camera, make certain that they have been set.

3 Make certain that your camera "sees" the subject you are photographing.

4 Make sure the camera is in focus. Don't get too close unless you are using close-up lens attachments.

5 Hold your camera steady as you gently squeeze the shutter.

6 Advance the film after taking a picture. In this way you are always ready to take another, if necessary.

7 When all of the film has been exposed, try to have it developed as soon as possible.

How to Hold a Camera Steady

Probably more pictures are spoiled because of camera movement. Failure to hold a camera steady results in pictures that are blurred. A few suggestions for holding a camera to prevent movement are:

1 Hold the camera firmly, using both hands with a finger on the shutter release.

2 Cameras with eye-level viewfinders should be held in both hands with the camera pressed tightly against your face. Your elbows should be pressed in against your body.

3 If the camera is a twin lens reflex that requires you to look down into a ground glass, then it is necessary to adjust the neck strap so the camera is at waist level and will be braced against

the body as you pull down on the neck strap.

4 Equally important is how you stand. Always brace your feet so as to maintain a steady balance. It is surprising how even a slight breeze can startle you and cause you to move. It does not take much movement to produce a blurred picture.

5 When taking time exposures, always use some method of resting the camera on a solid support. Do not attempt to hold the camera when taking a time exposure; it is almost impossible to avoid camera movement.

Squeeze, Don't Press the Shutter

Camera movement often results from not knowing how to operate the shutter release. It should be gently squeezed and not pressed or jabbed. Try to stay relaxed and hold your breath at the moment you operate the shutter to make an exposure.

What Is Composition?

Since this book is intended to introduce the beginner to the simple ways of pho-

Furled Sails. PAUL H. LEVIN.

tography, complicated methods along with "how to use professional-type cameras" have been omitted from earlier pages. A beginner might use a highly professional camera, but will not be able to take "good" photographs because he doesn't understand the camera. Strange as it may seem, the simple camera presents a similar problem. But pictures taken with a simple, non-complicated camera can be as good as those taken with an advanced, highly professional model.

No matter what kind of camera is used, photographs can usually be improved as long as certain basic rules of picture taking are followed. One of these is *composition*. Composition is the using of basic fundamentals to take a picture that will be liked by everyone.

Perhaps the best way to explain composition to the beginner is to list a few of the more important rules that should be considered when taking pictures.

►1 What About the Subject?
A good picture is simple. It deals with one subject or idea. This does not mean that "one subject" should be a single person or a lone object. As long as the picture tells a story that is not complicated or confusing, a single subject can be a picture of several people; of scenery that might be several buildings; or a collection showing one person's hobby.

Accidental or intentional! Avoid intruders! When looking through the viewfinder, make certain that unwanted subjects are out of the picture. It might be necessary to shift your subject and camera to avoid including strangers.

►2 Tell A Story
Good pictures always tell a story. It might be of a child holding a new toy; of proud grandparents looking at their newest grandchild; or even of a simple sign in front of a beautiful vase that tells us what we want to know. In each of these examples, pictures that might have been just snapshots have become storytelling pictures. Any simple snapshot can be made interesting by using a little imagination to make certain that it tells a story.

►3 Avoid Complicated Pictures
Later you will learn how to take complicated pictures intended for special use. For the present, however, to understand composition, it is important to keep it simple and avoid subject complication. As you look through the viewfinder, try to choose a camera position that will result in a picture where the area around the subject is uncluttered. Unlike the human eye, which can correct what it sees, the camera records what it sees. The camera cannot correct situations to create the picture wanted. For example, avoid taking pictures of subjects that appear to have trees growing out of their heads. Try to frame pictures of single and distant subjects or objects with trees or other objects. This will give pictures the illusion of 3-dimensional depth. Generally, try anything that you feel will improve the picture. Experience is a good teacher, and only practice and personal evaluation will show you how to create good pictures.

►4 Vertical or Horizontal
Some cameras take only square pictures. If, however, you have a camera that takes rectangular pictures, then it becomes necessary to decide how to hold the cam-

era. If the subject is long and narrow, the camera should be held so as to take a horizontal picture. When the subject is tall and thin, the camera should be held in a vertical position so that the picture taken will follow along with the shape of the subject. A simple rule to help you decide which way to hold your camera is to remember that the format of the picture should (when possible) match the format of the subject being photographed.

►5 Correcting Composition by Cropping

This is a laboratory (darkroom) tech

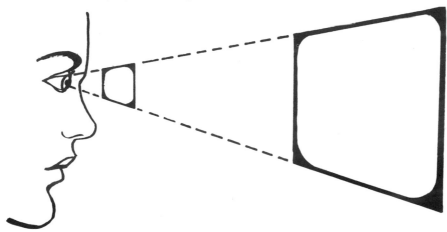

nique and will be discussed in greater detail later. For the present, cropping pictures is the process of correcting composition by elimination of unwanted areas. The area that remains is then reproduced as a finished photograph.

►6 Avoid pointing the camera upwards at a sharp angle or your pictures will appear grotesque and very unflattering.

The Viewfinder

All cameras have an accessory that allows

the camera to be aimed at the subject in order to compose the picture before clicking the shutter. This is the viewfinder.

There are many kinds of viewfinders, but discussion here will be limited to the two types generally found on the simple camera.

1 Most simple cameras have the *eye-level* type of finder which is a tube built into the camera. This has a series of lenses through which you sight the subject.

Eye-level finders should be used with the camera held close to the eye so that,

as you look through it, all four corners of the front of the finder can be seen.

2 Some cameras have *waist-level* finders which are used by looking down into the camera at a picture of the subject that appears on a sheet of ground glass. This type of finder is found on twin-lens reflex cameras.

Parallax and How to Avoid it

Sometimes the area of the subject as seen by the lens of the camera and the viewfinder differ slightly because of the

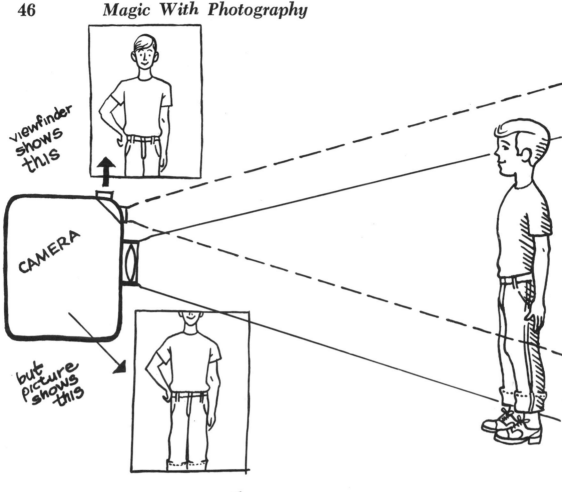

different positions they occupy on the camera.

This difference is referred to as parallax and is evident in pictures where the subject appears off-centre or when part of the top appears to be cut off.

The farther a subject is from the camera the less the problem of parallax to be concerned with. To correct for parallax, aim the lens of the camera and not the viewfinder at the centre of the subject. This is done by first composing the picture in the viewfinder and then tipping the camera just a little down or up as the situation requires. You will have to determine by experiment how much to compensate for. Always remember that increasing the distance between subject and camera requires less correction.

Five Easy Steps to Better Pictures

▶1 *Look first at what you are photographing.* If you want to take good pic-

tures, it is important to become subject conscious. For example, in taking a picture of a child playing with a new toy, move in close so that the picture includes only the child and toy and nothing else. But if you are taking pictures of landscapes, back off so that the entire scene will be recorded by your camera.

►2 *Make it simple.* The secret of good photography is simplicity. Simple pictures tell a story faster and more effectively. Pictures cluttered with too many points of interest tend to be boring.

►3 *Try different positions.* Move around before snapping the shutter. Taking different pictures of the same subject will produce many different effects. Instead of taking a picture head-on, try different angles. Look at your subject through the viewfinder at an angle from below, from above, the side, or even from behind. You might be pleasantly surprised at the interesting effect that will result.

►4 *Don't overlook the background.* Try to take pictures when the background does not interfere with the subject. Pictures tell better stories when there is nothing to distract your audience.

Fisherman's Silhouette. PAUL H. LEVIN.

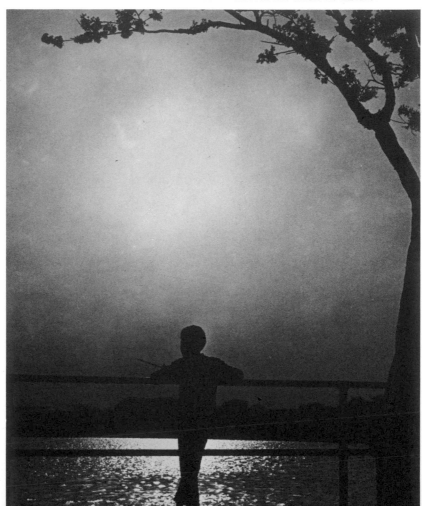

►5 *Pictures should always tell a story.* The most interesting pictures always tell a story. Pictures that appear artificial and that have a posed look are not very exciting. Always try to snap the shutter when there is a story to be told—somebody in the act of doing something—a child crying because he wants something he can't have—counting the pennies from a broken piggy bank—even a picture of someone snoring away after a big meal; etc.

Avoid posing your subjects too long. This tends to make people stiff and tired and results in pictures that lack interest and excitement.

Have You Ever Taken Pictures Like These?

One question asked most by beginning photographers is, "What happened, what did I do wrong?" Perhaps the following information will help the amateur to answer that question by showing him how to take better pictures. These are the mistakes often made with black-and-white film. Colour film will be discussed later.

1 *Underexposure* produces an overall dark or flat gray picture. Pictures taken in dark, shadowy areas should be avoided. Take pictures with subject in reflected sunlight. If indoors, check the batteries in your flashgun. Underexposure can also result from standing too far from the subject when using flash. Try moving in closer. Flash photography will be discussed later.

2 *Overexposure* produces a chalky picture lacking detail. Overexposure is the result of too much light as compared

Overexposed.

Underexposed.

to underexposure, which means not enough light. Make certain that the film you are using is not the extra-sensitive, very fast type (Unless in winter.). When overexposure occurs with flash, try moving back from the subject.

3 *Camera movement.* The entire picture (subject and background) is

Camera movement.

Subject too close.

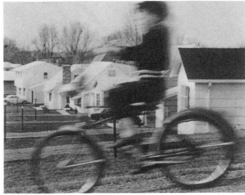

Subject movement.

Dirty lenses.

blurred. Are you holding the camera steady and clicking the shutter by squeezing it gently? Make certain that the camera is in focus. If you're not certain, have it checked. This point is included with movement because the results appear the same and are often difficult to distinguish.

4 *Subject movement.* Only the subject is blurred. The background is sharp. With the simple, non-adjustable camera, the subject will have to stand still.

5 *Dirty lenses* produce foggy, blurred pictures. Using proper lens-cleaning materials, clean the lens before taking pictures.

6 *Subject too close* means a fuzzy subject with a sharp background. Check your camera instruction booklet to see how close you can get.

7 *Finger (or neck strap) in front of lens* produces a black out-of-focus streak that appears across the face of the picture. Make sure that there is nothing in front of the camera that might get in the way.

8 *Heads chopped off* or pictures not centred. This is caused by parallax. Tilt the camera so that the lens and not

Neck strap.

Fogged.

the viewfinder is aimed toward the center of the subject.

9 *Edge of film is fogged.* This is caused by light leaking into a roll of film that is too loosely wound. Always load and unload a camera in the shade. Wind the film tightly and place it in the original carton for additional protection.

10 *No pictures.* Strange as it may seem, film was not put in the camera, or was not put in correctly so it could be wound into picture-taking position.

Some cameras have a cover to protect the lens. Did you remove it? Also possible is that the flashgun is not working properly to supply the necessary light when the lens is wide open.

11 *Again no pictures.* The film is developed and all you have are one or two all-dark (no detail) negatives and the rest transparent film. Have the camera checked by an expert repairman. This is to make certain that it is working properly and does not have a defective shutter or faulty film advance mechanism.

How Many Pictures Should You Take?

If you intend to take a series of pictures for use later on, then try to plan ahead what pictures you want to take. Always make certain you have enough film and flashbulbs. It doesn't hurt to bring along extra because you might find it necessary to take more pictures than planned.

Taking several pictures of the same subject is standard procedure for professional photographers. They do this to be certain they have taken a good picture and to provide a choice of pictures for use. When possible, it is always best to take a close-up, a picture farther away, and several pictures from different angles. This will give you several to choose from. You also might try taking indoor and outdoor pictures.

How many pictures you should take depends upon your ability to create different moods. If you have an idea, take the picture and decide later. Many excellent pictures have been lost by photographers who hesitated.

When Is There Enough Sunlight?

Simple cameras that are pre-set to take pictures with the shutter opening and closing in about 1/50 second have definite limitations.

For photography with black-and-white film there is little to be concerned about. As long as there is enough light to see by, the film latitude of black-and-white film will permit picture taking in many situations thought impossible.

However, if colour film is being used, the best time for exposing is from two hours after sunrise until two hours before sunset. The colour of daylight tends to change throughout the day and colour pictures taken in the morning will appear different from those taken in the afternoon.

Colour film is generally "balanced" for picture taking around midday. Light at this time will produce the most natural-appearing colours. Exposures made in the early hours of the morning before sunrise or in the evening after the sun has set, tend to have an over-all bluish colour.

Colour pictures made when the sun begins to appear over the horizon or just before it sets in the evening will produce pictures having a reddish colour. Always remember that light is what is recorded on the film and colour film will record the colours it sees.

Many photographers use the red and blues of early and late daylight to create dramatic and unusual pictures. Try experimenting a little when taking pictures; the results might surprise you.

The Different Kinds of Daylight

Knowing that daylight can produce different effects, what then are the results when the sun is at its brightest, when there are clouds in the sky that cut off some of the sunlight, when the sky is hazy, or when there are shadows?

By always using the same kind of film (that which is recommended by the manufacturer for your camera) you will soon learn from experience what can be done.

▶1 *Bright sun.* With the sun directly overhead (top lighting) unwanted shadows will fall on the subject. A person photographed in this light is likely to squint and will find it difficult to maintain an interesting, lively expression. By taking the picture with the sun off to one side (side lighting), you can achieve a soft, shadowy effect that will dramatize your subject and eliminate any uncomfortable feeling.

With the sun in back of your subject (back lighting), very few shadows are produced. One word of caution—make certain that the sun does not shine directly into the camera. If this occurs, unwanted glare may result that will spoil a good picture.

If there are any clouds present when the sun is bright, you can use them to filter the bright rays of sunlight. This will produce an over-all effect of a "softer" picture with few or no shadows.

▶2 *On hazy days.* Pictures taken on hazy days tend to be shadowless. Because there is less glare, there is little need to shift the camera to different picture taking positions.

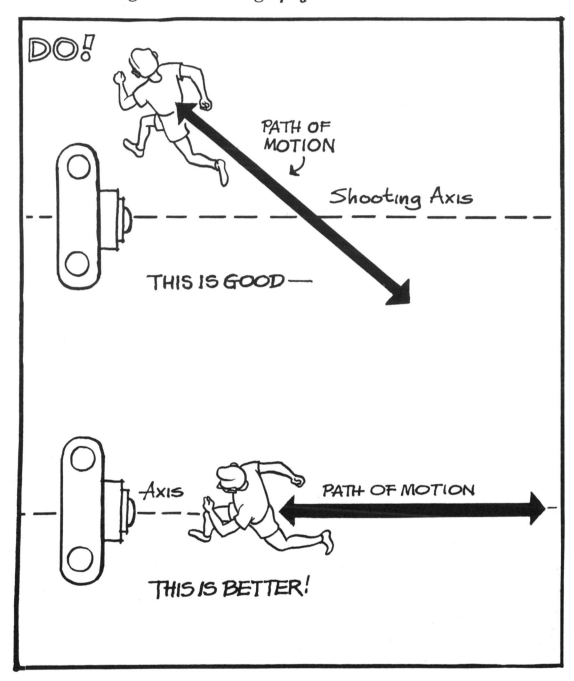

►3 *When shadows are produced.* Try turning the subject 90 degrees to obtain side lighting. This will, of course, produce a picture in which half is in shadows. If the shadows are not too great, the effect will prove very dramatic.

Taking Action Pictures

Despite the fact that the simple camera is limited in its use, it can be used to take many pictures that might be thought impossible. It can even be used for taking action photographs in which the subject is moving very fast.

When using a non-adjustable camera to take pictures of moving subjects, the camera should be aimed so that the action of the subject is moving in as straight a line as possible towards the camera. For example: A baby taking his first steps is the subject. (1) With the camera aimed so the baby is walking across the room in front of the camera, the background would be sharp, but the baby would be very blurred. (2) With the camera positioned at a 45-degree angle (diagonal) to the action of the subject, the background would still be sharp and the blur of the baby less pronounced. (3) If the camera is held so that the action is toward the camera in a straight line, no blur, everything sharp, and a good picture.

If the subject is moving at a high rate of speed, such as a diver jumping from a diving board, the technique is different. Follow the path of the subject, using the viewfinder. With the subject fully framed in the finder and with the camera still following, press the shutter. This will make a picture where the background is blurred and the subject sharp. With this technique you will have to realize that the closer the subject is to the camera, the more difficult it is to follow the action in the viewfinder. For good pictures, using this technique, you will need a minimum distance of 60 to 80 feet.

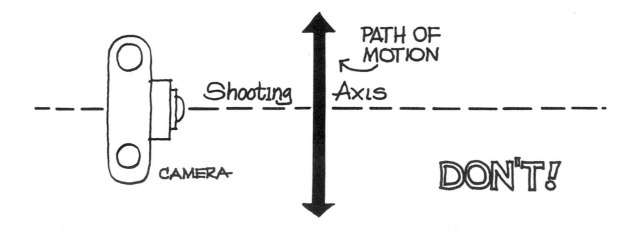

flash photography

What Is Flash Photography?

Flash photography is a method for taking pictures in places where there is not sufficient light. It is done by using special equipment that is capable of furnishing the light needed.

Even before the beginning of photography, when Thomas Wedgwood and Sir Humphry Davy made the first photograph, it was discovered that light was necessary to change certain silver compounds. As time passed, discovery revealed that only certain amounts of light would produce the results wanted. Too much light would cause overexposure and too little would result in underexposure. Experience will teach you that careful control of light is necessary to make good pictures.

Nothing could be easier than using flash to take pictures. With the simple, non-adjustable camera, just follow the manufacturer's instructions and you will never have to worry about the quality of your photographs.

A flash unit consists of a box into which batteries are placed. These batteries produce, when the shutter is pressed, a supply of electricity that triggers a flashbulb. The bulb produces a momentary flash of bright light that is focused onto the subject by a reflector. Some flash units are separate pieces of equipment and some are built into the camera.

Taking flash pictures with the simple camera is easy. There is nothing to adjust, just put a flashbulb into the reflector, aim the camera, and gently squeeze the shutter to take a picture.

What Are Flashbulbs?

Flashbulbs are self-contained units designed to produce light that can be used when exposing light-sensitive film.

They are similar to ordinary light bulbs with the following differences: (1) Depending upon the use and flash unit there are different size bulbs: (2) There is a metallic filler inside the bulb which when ignited burns to produce a brilliant flash of light: (3) The metal base that fits into the socket of the flash unit differs depending upon the size of the bulb and type of unit: and (4) There are blue and white (clear) bulbs which will be discussed in greater detail later.

Flashbulbs start with the "AG" (All

Glass) bulb. The newer "Magicube" does not require a battery.

Why Different Flashbulbs?

There are many different sizes and types of flashbulbs. The choice of what flashbulb to use is governed by two factors, (1) the flash unit which is designed to use a specific bulb, and (2) the type of film used.

The instruction manual (which should be read before taking pictures) explains what flashbulb to use. Don't let the size of some flashbulbs fool you. All are designed to deliver enough light to be able to take good pictures.

Most film (black-and-white and some colour) requires light produced by clear bulbs. However, most colour film must be exposed to the light from blue bulbs only. Using a blue bulb to expose black-and-white film will not matter too much, but not using the correct bulb with colour film will spoil the pictures. The film instruction sheet packaged with the film explains what bulbs should be used.

To identify blue bulbs from clear, the letter "B" follows the number of the bulb, such as AG1B, PF1B, etc.

Daylight colour film that requires clear bulbs can be exposed indoors by using blue bulbs.

If in any doubt about which flashbulb to use, read the instructions that came with your camera or consult a photographic dealer.

About Those Batteries

Good flash photography requires that batteries be fresh and up to full strength.

Make sure that contacts and terminals are clean. Dirty or corroded contacts and weak batteries will not produce enough power to fire a flashbulb. When they are dirty, follow the manufacturer's recommendations for cleaning. If corroded, it will be better to replace the batteries.

There are many types of batteries to choose from. One of the newer types, the manganese-alkaline battery, is a little more expensive than regular zinc-carbon batteries. Alkaline batteries last longer and provide more dependable power.

Alkaline batteries should be used only in units that have silver-plated contacts. Flash units that have copper or brass contacts require that zinc-carbon batteries be used.

When Flashbulbs Don't Fire

▶1 Check batteries.
Make certain that the batteries are the kind and size prescribed for your flash unit.

Test the batteries; make sure the voltage is up to strength.

When purchasing new batteries, always have them tested.

Check the terminals to see if they are dirty or corroded.

Batteries will work only if put into the flash unit as specified by the manufacturer. Check to see if this has been done.

Try new batteries if still in doubt.

Check to see if battery compartment is closed. Contact will not be made if cover is left open.

▶2 Check flash unit and electrical contacts.

Check to see that contacts are clean.

Even a thin film of grease (from your fingers when putting in the batteries) that is invisible can prevent contact from being made.

►3 Check the flash unit.

If the flash unit is a separate unit, check all connections between it and the camera. Make certain that they are clean, tight, and not damaged.

Sometimes, when handling, the spring terminals in the flash unit bend. Tight contact between batteries and terminals can be maintained by carefully bending the metal terminals. ◆

►4 Check the flashbulbs.

Has the flashbulb been inserted into the socket correctly?

►5 If none of these work—

have your flash unit and camera checked by a repairman.

What Is Synchronization?

Synchronization is the relation between the time the shutter opens and the flashbulb fires.

Most cameras have built in an automatic unit that permits a delay between the time the shutter begins to open and when it is completely open, and when the bulb fires. There is also a lapse of time between the flash of the bulb and the moment of its maximum brightness. Synchronization is adjusting the shutter so it is fully open when the light from the bulb is at its peak.

Since there are many different kinds of flashbulbs, each type having different maximum flashing peaks, it is important to use the bulb suggested by the manufacturer. Don't guess, check your instruction manual.

Flash with the Simple Camera

Setting a camera to take flash pictures depends upon three things: (1) the speed of the film; (2) the amount of light the flashbulb produces; and (3) the shutter speed.

With the simple camera there are usually no adjustments to be made, the manufacturer already having done these at the factory. All you need do is to use the recommended film and flashbulbs. Some simple cameras might require the setting of an adjustment from daylight to flash. Any important information on how to take the picture will be found in the instruction manual or the information brochure packaged with the film.

Combining Film and Flashbulbs

With some subjects it is easier to take pictures with flash than it is to take them outside. With flash it is easier to control the light. It allows you to work more closely with your subject to obtain, with careful planning, better pictures.

When we talk about film we are referring to a large group of light-sensitive materials designed to record a picture when exposed to light. There was a time when photographers only had a few to choose from. Today there are "slow" films for use with very bright light; "medium" films for average conditions; and "fast" films when there is not enough light.

Simple, non-adjustable cameras are designed to use, in most cases, film that is from the middle group or medium

speed. When combined with the recommended flashbulb, it becomes an "all-round" film that will make good pictures.

Flashbulbs can be used also for outdoor photography to supplement the light when taking pictures in the shade. It is not necessary to change camera settings when using supplemental flash outdoors. Always remember to check if the correct bulb is being used using blue when the film requires it. Supplemental flash outdoors will help to brighten and soften any harsh shadows created by sunlight.

Always check your instruction manual to find out how close you can get to the subject. Too close, and the picture will be overexposed. Too far away and you will have an underexposed picture.

Setting Your Camera for Flash

►1 Load your camera with film.

►2 Make certain the batteries are up to full power.

►3 Put a flashbulb into the flash unit.

►4 Make certain that you are at the correct distance from the subject.

►5 Aim the camera using your viewfinder.

►6 Squeeze the shutter.

►7 Before proceeding with step 2, make certain that your camera is not one that has an adjustment that must be made for regular exposures or flash.

Simple Exposure Guides for Flash

Packaged with most film are instruction sheets that contain laboratory-tested information necessary for taking good pictures. Some of the information supplied will be on (1) camera settings (when needed) for daylight and artificial photography, (2) taking indoor and outdoor pictures without flash and with flash, (3) hints for taking better pictures, etc. Helpful guides that can be purchased reasonably cheaply are snapshot guides. These are pocket-size cards with information printed on them. By rotating a dial that has printed on it the different kinds of film and setting it opposite the lighting situation, you can determine the camera settings necessary to take good pictures. There are many different guides that can be purchased for special purposes. Don't sell these short, they can save many rolls of film by helping to produce better pictures.

Tips for Better Pictures with Flash

About safety and maintenance. There is little to be concerned about when taking pictures using flashbulbs. However, there are a few precautionary steps that should be followed:

►1 For safety purposes.

Some flash guns have transparent light shields. If supplied, these should always be used.

Flashbulbs, after firing, are very hot and should not be handled with bare hands. Wait a few seconds for them to cool, or eject them by pressing the ejector button that you will find on most flash units.

Always insert a bulb into the flash

unit before connecting the cord to the camera. This will prevent a bad burn because of premature, accidental firing.

Do not, under any circumstances, experiment with house current for firing flashbulbs. Flash units are designed to use battery electricity and anything else will prove disastrous.

Remember, if the bulb does not fire: (a) first check the batteries; (b) then check to see if all contacts and terminals are clean; (c) if necessary, have the camera and flash unit checked by a camera repairman.

►2 A few ideas that might prove helpful:

Don't be afraid to take flash pictures of babies. The flash of bright light will not harm them. Sunlight or bright photofloods can do more damage.

To prevent harsh shadows when the subject is standing too close to a wall, move the subject forward, a few feet away from the wall.

When taking pictures of people (especially children) change your camera position. Try taking the picture with your camera pointed slightly downwards. This will result in a more natural picture, with more even lighting, than if it were taken with the camera on a level with the subject.

Check the background to make certain that there are no reflective surfaces that might cause the light to bounce back into the camera, producing glare.

On-the-Camera Flash

Most cameras are designed so that the flash unit is a part of the camera and is not removable. Taking pictures with this arrangement has its advantages. The camera is always ready for instant flash. It's foolproof in its operation. For the beginner this is the best possible arrangement. There is no complicated guesswork involved because the manufacturer has designed the unit to be self-contained and for maximum efficiency in simple picture taking.

Despite the disadvantage that pictures made with on-the-camera flash are usually flat and have harsh tones, many photographers have come to depend upon this type of arrangement because of its foolproof simplicity.

Off-the-Camera Flash

If your camera has a removable flash unit, more effective light control can be maintained making better pictures.

Lighting control allows you to aim the flash unit where you want, minimize shadows, and achieve depth when taking portraits. If you find the length of cord between camera and flash unit too short, it can be lengthened by adding an extension cable.

As a beginner, experiment with a roll of film, holding the flash unit at different angles. Record reference notes about each exposure for future use. It is important to remember, when taking pictures with off-the-camera flash, always to keep the distance of the flash unit from the subject the same as is the camera. This is to prevent possible over- or underexposure.

Special Photographic Techniques

Now that you know the basic techniques

of flash photography with a simple camera, there might occur an occasion when you would want to try taking pictures with equipment that is more versatile.

The following are a few of the more popular types of photographic accessories and ideas that will show the amateur photographer how, with study and practice, photography does not have to be limited to the simple camera and simple picture taking.

Using More Than One Flashbulb

There are some flash units that have been designed for multiple-flash hookups. The extra equipment required—extension cords, flash holder, and lamp stands—is worth the small investment when more than one flash bulb will produce a better picture.

Multiple-flash photography is easy. It consists of connecting a second flash holder to the main unit, using a plug-in extension cord. Pressing the shutter of the camera fires both units at the same time.

Using more than one flashbulb means more light, and more light requires a camera that can be adjusted to compensate for the extra light. The exposure for multiple-flash is calculated by figuring the exposure for the main bulb and then closing the lens opening (diaphragm) by half an f/stop.

When using two flashbulbs with (1) colour film, both bulbs should be the same distance from the subject; (2) black-and-white film, the second bulb should be a third of the distance farther away from the subject than the main bulb.

Photography with one flashbulb often produces unwanted shadows. The idea behind the use of multiple-flash is to arrange the position of the second bulb so it will fill in the dark areas (shadows) created by the main bulb. Experimenting with the location of the bulbs will produce many interesting and different lighting effects.

What Is Bounce Flash?

Bounce flash is a professional way of making pictures that have a soft quality without the usual shadows. Bounce flash requires a flash unit that can be aimed away from the subject so that the light "bounces" off a surface to illuminate the subject. It's important that the surface used is smooth and coloured white. Coloured surfaces will reflect unwanted colours and dark surfaces will absorb too much light.

Once again, a camera that can be adjusted must be used when taking pictures with bounce flash. How to set the camera can prove to be very complicated. First, take a picture with the camera set at the suggested lens opening, forgetting that the flash unit is pointed away from the subject. Next, take a picture with the camera set with two openings larger, then with one opening larger. Now set the camera two openings smaller, and then just one smaller. Try always to use a neutral surface to bounce the light, and maintain the same distances of camera to subject and flash to bounce surface to subject. With these suggestions future bounce flash exposures should not present any difficulties.

What Is Open Flash?

Some cameras, often many of the older models, cannot be used to take flash pictures. Flash synchronization was not built into them. However, flash pictures can be taken by using a method known as "open flash."

It is based upon the fact that film will not record an image unless there is enough light. The following steps explain how to take pictures with open flash.

1 Check the film instruction sheet for the recommended distance the camera should be from the subject for flash. Secure the camera, using a tripod or clamp, so it cannot be moved.

2 Set the shutter for B (bulb) or T (time).

3 Set a flash unit at the correct distance from subject and camera.

4 Have someone turn out the lights and open the camera shutter. Fire the flashbulb and then make certain the shutter is closed before turning on the lights.

5 Open flash is simple . . . this is all there is to it!

What Is Electronic Flash?

With the recent invention of a way to pack miniaturized circuits and electrical components into very small boxes, science has developed a unit known as electronic flash. It is totally different from the conventional units you have already worked with.

It does not use a flashbulb. Instead it has a gas-filled bulb activated by elec-tricity, which can be used for many thousands of pictures. The electricity is often supplied by batteries that are a part of the unit. These batteries can be recharged by plugging into house current. Some of these units work on house current as well as batteries. The initial expense of electronic flash units is fairly high, but they soon pay for themselves when you realize that there are no flashbulbs to replace.

One advantage of taking pictures with electronic flash is that the current used to fire the bulb and the amount of light produced always remain the same. This allows for balanced picture control at all times.

Ordinary flashbulbs are designed to fire in about $1/75$ to $1/200$ seconds. This is fast enough for ordinary photographic purposes. Electronic units fire in about $1/500$ to $1/5000$ seconds which is fast enough to "stop" anything that moves. Because cameras must be built to use electronic flash, simple cameras cannot be used, and you will have to be satified with flash photography using conventional flashbulbs.

Flash Photography in Sunlight

When there is not enough light, film in a camera will not record an image. Always remember that light is a factor that can determine the quality of a photograph. When taking pictures, remember that there are different kinds of daylight that will produce different effects on the same subject. Also, it is not always possible to use the best position in order to use the available light most effectively.

In black-and-white photography a good picture is one in which the many colours of the subject are rendered as shades of grey that create an atmosphere of feeling that can be described in terms of depth, warmth, interest, and finite detail. Sometimes it is not possible to capture on film the picture wanted unless sunlight is supplemented by artificial light.

Flash photography in sunlight, referred to as fill-in lighting, is used to create detail instead of shadows. It produces detail photographs that are three dimensional instead of the uninteresting two-dimensional or flat pictures.

When taking flash pictures in daylight, if the flash unit is removable, be sure to hold it a few feet farther away from the subject than it would usually be held. Too much extra light will ruin the natural light effect produced by daylight. The result will be a washed-out photograph.

Since the flash unit found on most simple cameras is not removable and the amount of light needed can fluctuate, it is necessary sometimes to reduce the amount of light. This can be done by covering the reflector with several thicknesses of a white handkerchief. Close-up photography requires from one to three

Without fill-in flash.

Using fill-in flash.

thicknesses. As you move back from the subject, decrease the thickness of the covering. You might have to experiment to improve the quality of the picture desired. This can be done by taking several pictures using different degrees of covering each time. You can then choose, after developing, the best picture.

When using colour film, make certain that a blue bulb is used.

Dusk on the River Raft. PAUL H. LEVIN.

Silhouette at Dusk. PAUL H. LEVIN.

the photographic darkroom and equipment

Discovering the Fun of Photography

Your interest in photography will determine whether you skip this chapter or read it and try the experiments that show how to develop film and make finished prints. This can be a lot of fun and is not too difficult.

Many photographers are content to take pictures and leave the developing to someone else. How to develop films and print pictures is much simpler than people imagine. The only experience required is the ability to follow directions.

Before You Begin

To develop film and make prints from negatives, the first requirement is the room in which you will work. The room must have two things: (1) complete darkness; and (2) a source of water.

First let us consider the degree of darkness. Many films require complete darkness. Accidental exposure to light will ruin undeveloped film. There are some light-sensitive materials that can be developed with the aid of a special light to be described later. As a general rule, always remember that, when working with light-sensitive materials, they can be spoiled if exposed to light before the developing process is completed. Always be certain to read the manufacturer's instructions enclosed with light-sensitive materials before starting.

The second requirement is a source of water. It need not be in the darkroom as long as it is available close by. Water is needed for preparation of chemical solutions and for washing developed films and prints.

Where to Work

Any room that can be darkened will do. A room that has been built as a permanent darkroom is a great convenience. If such a room is not available, then the kitchen or bathroom can be used. Of the two, the kitchen is probably better because there is usually a table available, cabinets in which to keep supplies and equipment, and a sink with running water. If using the bathroom, place a large board over the tub to provide a working area.

Other helpful equipment includes a supply of paper towels, electrical outlets, and an exhaust fan. The chemicals should be kept in dark bottles and stored in a cabinet away from foods and medicines to avoid mistakes. Have handy a large dustbin in which to dispose of

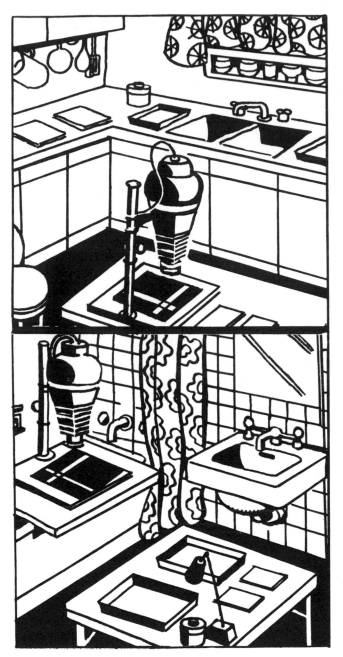

used materials. All chemicals should be disposed of by flushing down the sink with running water.

The combination of a well-planned work area with knowledge and understanding is a sure way to guarantee successful production of photographs. Plan your work area so there is a minimum of movement or waste motion. Check to see that you have ready all the necessary equipment and chemicals before beginning. Provide a way to warn people to *keep out* while you are working.

There's Nothing Fancy About a Darkroom

Once you have decided upon the room

in which you will work, the first thing that must be done is to cover up all light leaks. The windows can be covered with heavy cardboard held in place by masking tape around the edges. Towels can be placed at the bottom of the doors to cover light leaks. Before beginning, turn off the light and wait five minutes for your eyes to adjust to the darkness. Within that time any light leaks overlooked will become visible and can be covered up.

When working with chemicals it is suggested that you wear old clothes or a rubber apron to protect your clothing from accidental splashing of solutions. Some are liable to cause stains.

One of the most important things to remember is to keep your work area clean and orderly. Always clean up after you finish. Dirt and dust can spoil film and paper. Always spread newspapers over your work area.

The Basic Darkroom Equipment You Will Need

The beginning photographer can purchase a set containing all the basic equipment needed to get started in photographic developing, or purchase the following equipment separately:

4 trays 5 by 7 inches approx.	1 32 oz. graduate
1 red safelight	1 sponge
1 thermometer	1 contact print frame
2 print tongs	
2 glass stirring rods	1 plastic funnel
10 film clips	1 packet normal grade printing paper
1 bottle of stop bath solution	1 packet of hypo
1 film developing tank	4 packets of developer
	1 blotter book

Much of this equipment can be found around the home or purchased at the ironmonger's. Glass or plastic dishes can be substituted for the trays. Do not use metal pans or trays because the chemicals will react with the metal and spoil your pictures.

Films and printing papers have different degrees of sensitivity to light and in processing there are some that must be developed in total darkness and others that can be processed with a safelight used for illumination. Be certain to read the manufacturer's instructions to learn if a safelight can be used. A safelight is nothing more than a light covered with red material so that only the rays of red light will illuminate the working area. An adequate home-made safelight can be made by fastening a sheet of red cellophane over an ordinary desk lamp, or replacing the white bulb with a ruby-red bulb.

You should buy a thermometer. Photographic thermometers are available in several styles. Purchase one with a stainless steel back and a hook so that it can be hung over the edge of the tray.

Print tongs can be made by taking two pieces of plastic, each about one-half inch by ten inches, separating them at one end with a small block of wood about one-half inch thick and fastening them together with rubber bands.

For making prints from negatives you will need a printing frame. A printing

Fishing Off the Rocks. PAUL H. LEVIN.

frame is used to make certain that the negative is held in tight contact with the light-sensitive paper. A photo printing frame that will give excellent results can easily be made from two pieces of window glass, a sheet of heavy black paper, and two heavy rubber bands. The negative and sensitive paper are placed between two pieces of black paper. The top sheet has an opening the same size as the negative. The bottom sheet is to prevent backlight. Place the paper and negative between the black paper, then between two sheets of glass and fasten together with rubber bands.

You should be able to purchase at a scientific apparatus dealer's two pieces of glass tubing which can be used as stirring rods.

Ordinary wooden or plastic clothes-pegs can be substituted for film clips. To prevent chemical reactions that will spoil the chemicals, do not place metal springs in the solutions.

In a later chapter we will talk more about the printing paper used for making positive prints. For the present, however, to complete your supply of necessary materials purchase a packet of normal grade printing paper the same size as your negatives. As for the chemicals, instead of buying separate packets of developer, stop bath, and hypo, Eastman developing outfits can be purchased. However if you plan to continue with developing, it is more economical to purchase the chemicals in larger individual sizes.

Other equipment which you will need and should be able to find around the house is a glass or plastic funnel, a pair of scissors, a 60-watt light bulb, and a torch. From the chemist you should be able to obtain several dark brown bottles for storing chemicals. Before using, be sure that they are clean.

In some of your experiments you will need chemicals that can be purchased at your local chemist or a hobby shop that sells chemicals in small quanti-

ties for the amateur scientist. Some are available at any well-stocked photography shop.

Many photographic stores often feature sales of film, paper, chemicals, etc. at very low prices. Sometimes it pays to buy some extra for future use.

When stockpiling extra film and paper, consideration must be given to its storage. It's very important that the seals on the packages are not broken and that all extra supplies be kept in a cool, dry, and dark place. Always check the expiration date on the packet to be sure that you will use it before it expires. Always remember that light-sensitive materials spoil upon prolonged standing and this is quickened by exposure to heat and dampness.

After exposing film, try to process it as soon as possible. If on holiday, have exposed film developed and when you arrive home you can make prints from the negatives. Many amateur photographers find the making of prints the enjoyable part of darkroom science and leave the developing of films to others.

A Problem of Storage

How can negatives and prints be protected from damage so they can be used again?

There are many methods of filing negatives and prints. The following is one that has been used with great success by the author.

Negatives can be filed in cellophane or glassine envelopes that can be purchased from any photography or stationary shop. Each envelope should be marked with an identifying number that corresponds with a similar number on the back of the print. Always write on the envelope before placing the negative inside. This prevents scratching the negative.

These envelopes can be kept in a box designed for this purpose. The box should be stored in a cool, dry, and dust-free place. Another popular method is to glue these envelopes onto pages of a notebook overlapping shingle fashion.

There are many ways to display prints, and ideas for doing this will be described later. In order to prevent damaging prints that can't be stored, a very popular method for preserving them is the use of photograph albums. Different albums should be used for each general subject. One album might be pictures taken on a vacation trip; another at birthday parties; at family reunions; etc.

Photographic prints not mounted often tend to curl. They can be flattened by moistening the backs with a dampened piece of cotton, putting them between two blotters, and placing a heavy book on top until dry.

the photographic process

The Latent Image

After the film has been exposed to light, the camera is taken into a darkroom where the film is removed. If it were possible at this stage of the photographic process to examine the film without spoiling it, nothing would be seen. Pictures made by exposing film to light are recorded as invisible images and are referred to as latent images.

With all the knowledge and understanding that science has brought to photography, no one knows with any certainty exactly what a latent image is. Since the beginning of present day photography there have been many theories. One of the more recent explanations theorizes that latent images are submicroscopic particles of silver that form when light is allowed to come into contact with light-sensitive silver compounds. It has also been observed that the amount of change is in direct proportion to the amount of light.

Photographic Developers

To change latent images into visible pictures the exposed film is treated with certain chemicals. This process is known as developing and the quality of the picture that appears depends on the amount of silver produced when the film was exposed to light. Under normal circumstances, developing chemicals will have little or no effect on film not exposed to light.

Developing is the treatment of exposed film with a solution of chemicals that changes (reduces) the exposed silver compounds to metallic silver. Many chemicals can be used for this purpose, and in modern photography the chemicals used most are hydroquinone, pyrogallic acid, Amidol, or Metol. The process is a simple one: silver bromide when treated with one or more of the reducing chemicals is changed to metallic silver.

In addition to the reducing agents, there are other chemicals that must be added to the developing solution. The reducing agent will not function properly unless the solution is alkaline. Sodium carbonate or borax are often used to make the solution alkaline and are called activators. The activator also softens the gelatin, making it swell. This lets the reducing agent reach all areas of the emulsion.

Reducing agents spoil very rapidly and become inactive because of their affinity to oxygen which they absorb from both air and water. Using inactive developing solutions can cause stains on the film. Sodium sulphite is usually

added to prolong the useful life of developers and is called the preservative. It prevents any reaction between the reducing agent and oxygen.

To prevent unexposed film from being affected by developers, a chemical called a restrainer must be added. Potassium bromide is generally used, making the reducing agent more selective so it will react only with exposed silver compounds. This prevents any possible development of unexposed silver compounds which would result in a fogged appearance of the film.

Basically this is the action of developing solutions. There are many formulas for photographic developers, each intended for a specific purpose.

What the Stop Bath Does

After developing and before proceeding further, it is necessary to stop the action of the developer. This is done by: (1) washing in water; or (2) stopping the action of the activator by neutralizing it with acid. Usually a very weak solution of acetic acid is used (2½ or 3%).

Any developer carried over into the fixing solution will quickly deactivate the hypo and cause stains to form on the film.

Why Use a Fixing Solution?

At this point, undeveloped silver compounds that will turn black if exposed

Study in Steel. PAUL H. LEVIN.

An Old Man. PAUL H. LEVIN.

to light still remain on the film. To avoid spoiling the negatives, these compounds must be removed. This is usually done by treating the developed film with a solution of sodium thiosulphate (hypo). Again the process is a simple one and is explained as follows: when silver bromide is treated with sodium thiosulphate it forms a soluble complex chemical compound (sodium silver thiosulphate) that dissolves in water. This leaves the metallic silver that appears on the base as a negative.

Fixing solutions also contain other chemicals. To harden the gelatin softened by the developer, potassium alum or chrome alum is added. Once again a preservative must be used to prevent spoiling. Sodium sulphite is the preservative used most. However, it is liable to react with the alum, causing it to break down. To prevent this, acetic acid is added when potassium alum is used and sulphuric acid when the hardening agent is chrome alum.

It is very important that the preservative, the acid, and the alum are mixed together in certain ratios to prevent the acid from decomposing the sodium sulphite which would produce sulphur. Each of these ingredients helps to maintain the stability of the other. In fixing solutions that contain potassium alum a little boric acid is often added to prolong the life of the solution, but properly compounded fixers are easily bought.

Why the Final Washing?

Failure to remove all chemicals after fixing is liable to result in stains or eventual fading of the picture. To prevent this, wash developed negatives in running water for at least thirty minutes. Then let the film dry and cut it into individual negatives that can be used to make positive prints.

When Developing, Time and Temperature Are Important

The instructions in the next experiment explain how to develop film into negative. During the developing process, unless there is adequate control during all steps, the developing process will result in negatives that are either too light (underdeveloped) or too dark (overdeveloped). Negatives such as these cannot be used to make good prints (positives).

To avoid making under- or overdeveloped negatives one must follow a technique known as time-temperature control from beginning to end of the developing process.

Laboratory experiments have discovered that warm (above normal) temperatures will speed up photographic processing reactions and cool (below normal) temperatures will slow them down. Failure to maintain recommended temperatures requires a proportionate increase or decrease in the amount of time that film and papers must be chemically treated to make good negatives and prints. When the temperature is too warm, overdeveloping occurs. When too cool, underdeveloping is the result. Follow the temperatures as explained in the next experiment and you should have no problems.

As you progress in your understanding of developing, you will find that different developers and light-sensitive materials require different times and temperatures. Once again it is suggested that you read the instructions supplied with your materials to ensure that you are maintaining the correct temperature and time as recommended by the manufacturer.

EXPERIMENT

Developing Film

MATERIALS: Exposed black-and-white Verichrome Pan film; developing tank; thermometer; cylinder; film clips; developing chemicals; 20-oz. dark brown bottles; darkroom timer or clock.

WHAT TO DO:

Before You Begin

1 Because film-developing tanks made by different manufacturers often differ slightly in their construction, explanation of how to use your tank will not be given here. Instead, since the instructions supplied by the manufacturer are usually adequate, read them several times before attempting to use the tank.

2 Fill a large pitcher with lukewarm water and adjust the temperature to approximately 68° Fahrenheit. This can be done by the addition of small amounts of cool or warm water. Following the directions that come with the chemicals, dissolve each in separate portions of water, bringing them up to the

correct volume. Until ready to use, these solutions should be kept in tightly stoppered, dark brown bottles. Do not prepare these solutions too far in advance because they might deteriorate by the time you are ready to use them.

Developing the Film

As soon as you have completed the above, you are ready to begin developing the exposed film. Steps 3, 4, and 5 *must be done in a darkroom.* The rest

can be done in daylight without danger of ruining the film.

3 Take your film and developing tank with the correct size reel into a darkroom. Close the door and turn off the lights. Wait a few minutes for your eyes to adjust to the darkness.

4 Tear the "exposed" sticker seal and carefully unwind the backing paper until you reach the film. Carefully slide the end of the film onto the reel.

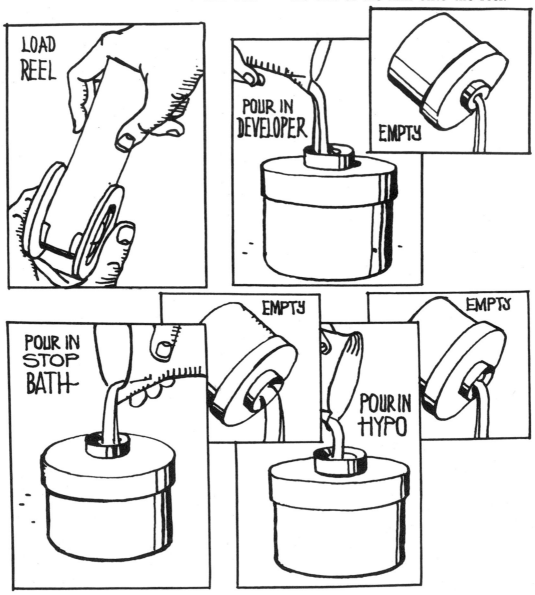

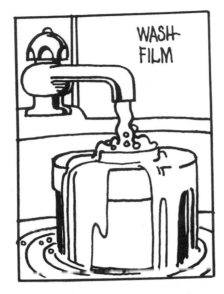

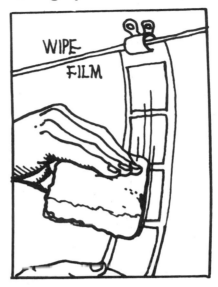

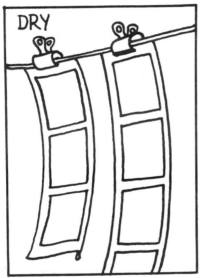

developing time as recommended by the manufacturer, pour out the developer. *Important . . . do not open the tank!*

7 Next, pour in the stop-bath solution, carefully agitating the tank for about 15 seconds. Pour out this solution.

8 Fill the tank with the fixer (hypo) solution, gently shaking again for 5 to 10 seconds of each 30 seconds. Treat the film with this solution for 2 to 4 minutes, or as recommended by the manufacturer, and then pour out the liquid and remove the cover. Do not remove the reel.

9 The developed film should be washed by allowing a *slow* stream of cool water to flow into the tank. At the end of 30 to 45 minutes, take the reel out of the tank, and remove the film. Important . . . remember that the emulsion is soft and to avoid any possible damage, handle the film by fastening a film clip to each end. Hang up the film in a dust-free area and with a damp sponge, carefully wipe the film with a straight, downward motion to remove any excess water. Finally let the film dry.

5 Holding the film by the edges (to avoid getting fingerprints on the film), carefully guide the film into the reel. Detach the film from the backing paper and place the reel into the tank. Cover the tank and turn on the lights . . . you are now ready to begin developing.

6 Begin timing as you pour the prescribed amount of developer into the tank. Gently agitate the tank by shaking in a circular motion for 5 to 10 seconds of each 30 seconds. At the end of the

What Is Printing?

A sheet of light-sensitive paper is placed in contact with a negative and exposed to light. After exposing, the latent image on the paper is developed using the same solutions and procedures as when developing film. Printing produces pictures where the blacks of the original subject appear black, and the whites are white. Photographic prints are referred to as positives.

Photographic film is very sensitive to light and usually must be developed in total darkness. Photographic printing paper is not as sensitive and can usually be developed using a safelight for illumination. This lets us see what we are doing and allows for some control so as to be able to make better prints.

EXPERIMENT

Making Positive Prints

MATERIALS: Negatives (from previous experiments); 4 trays; thermometer; graduate; safelight; developing chemicals; Kodak Velox No. 2 paper (size of your negative); blotter book; print tongs; printing frame; 100-watt frosted bulb; 20-oz. dark brown bottles.

WHAT TO DO:

Before You Begin

1 Fill a large pitcher with lukewarm water and adjust the temperature to approximately 68° Fahrenheit. This can be done by the addition of small amounts of cool or warm water. Follow the directions that come with the chemicals and dissolve each in separate por-

tions of water, bringing them up to the correct volume. Until ready to use, these solutions should be kept in tightly stoppered, dark brown bottles. Do not prepare these solutions too far in advance because they are liable to deteriorate by the time you use them.

2 In your darkroom, arrange four trays going from left to right as follows: In the first, pour the developer; in the second, fill with shortstop; in the third, pour the hypo; and fill the fourth tray with water.

Making the Prints

As soon as you have completed the above, you are ready to begin making positive prints. In this experiment, steps 3, 4, 5, 6, and 7 *must be done in a dark-room.* The rest can be done in daylight without danger of spoiling the prints. During steps 3 to 7, a red safelight can be used.

3 Begin by removing a sheet of paper from the package of photo printing paper. Make certain that the rest of the paper in the package is then closed to protect against exposure to light.

Place the negative into the print frame, dull side up and centred in the cut-out section of the black paper. Place the paper, shiny side down, over the negative. Close and secure it tightly to prevent it from opening accidentally. Turn the frame over so that the negative is on top and can be exposed to light through the opening in the frame. Expose it to a 100-watt frosted light bulb for approximately 15 seconds. The bulb should be 12 to 15 inches away from the frame.

4 Turn off the light and open the frame. Remove the paper and using

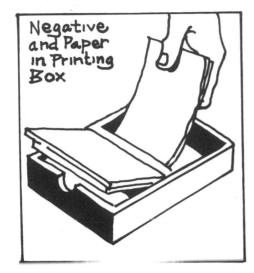

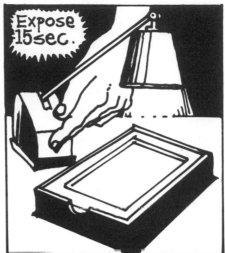

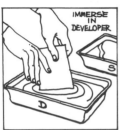

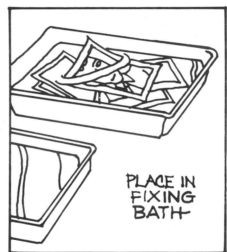

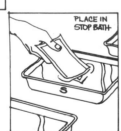

tongs, slide it, shiny side up, into the developer. Gently rock the tray until a picture appears. Using tongs, remove the paper after a satisfactory picture has developed, and place it in the shortstop solution.

5 Let the paper remain in the stop bath for 15 seconds while the tray is gently rocked.

6 With tongs, remove the print and place it in the fixer. Again the tray must be rocked in order that all of the paper is treated.

7 After the print has been in the hypo for 45 seconds to a full minute, the lights can be turned on. To fix the prints so that they will be permanent and will not fade, they should be left in the hypo for at least five more minutes.

8 Finally, remove the prints and let them drain for a few seconds. They should be washed in running water for 30 to 60 minutes. The temperature of the water should be maintained between 65° to 75° Fahrenheit and should be a very fine stream to avoid damage to the prints.

9 Remove the prints, let them drain, and then place face down into a blotter book. They should not be handled until dried. To avoid unwanted curling of the paper, when dry, place a heavy weight on top of the blotter book.

Ferrotyping Produces Glossy Prints

Some printing papers are designed for additional treatment which will produce a high gloss. This is accomplished by placing the prints face down onto a highly polished metal plate, also known as a "glazing plate." The wet prints are squeegeed or rolled into firm contact and left to dry until they peel off by themselves. This produces the high gloss seen in positive prints.

Glazing plates should be washed with mild soap and warm water to prevent sticking. Always use a soft sponge to wash the tins.

What Is Toning?

Pictures developed on regular photographic printing paper may not appear pleasing because of the gray-to-black colour. A more pleasing colour can be obtained by using a process that photographers refer to as toning. This is done by changing the metallic silver into another compound, not sensitive to light and which has a different colour.

Sepia toning is a popular process and consists of changing the metallic silver to silver sulphide. It's done by first bleaching out the silver and then re-developing it with sodium sulphide. There are other methods of sepia toning as we will see in the next experiment. Sepia toning produces a colour that can be varied from a rich brown to almost black.

Toning can be done by replacing the metallic silver with some other metal. Salts of iron, platinum, gold, and copper can be used to change the black to gray to green, red, brown, blue, and/or other colours.

The chemical reaction is a simple one. The original silver of the print is removed by the toning solution. The metal in the toning solution is then deposited in its place. Various com-

pounds of metals have their own specific colour, which allows the photographer to select from many, depending on the effect desired.

EXPERIMENT

How to Tone a Print

MATERIALS: Calcium oxide; powdered sulphur; distilled water; photographic prints.

WHAT TO DO: Mix together in a cup of distilled water one-half teaspoonful of calcium oxide and one-half teaspoonful of sulphur. Heat slowly until dissolved, filter and pour the clear liquid into a glass tray.

Place a photographic print into this solution for about thirty minutes, making certain that it is completely immersed. Using tongs, remove the print and wash in a slow stream of cool running water for several minutes. Examination of the print will reveal that the black-and-gray of the picture has changed to a warm brown sepia color.

WHAT HAPPENS: Changing the black color of the metallic silver to other colors is known as toning.

In this experiment, calcium oxide and sulphur react to form calcium sulphide. This reacts with the silver in the photograph to become light brown (sepia) silver sulphide. Silver sulphide is not sensitive to light.

What Is Reversal?

If positive images are wanted instead of negatives, a developing process known as reversal must be used. The process is a simple one. In addition to being used for making black-and-white positives and slides for projection, it is also used when developing many types of colour film.

When using the reversal process, the film is first developed using regular developing chemicals and standard procedures. After the silver compounds have been converted to metallic silver, the film is treated with a bleaching solution instead of hypo. This serves to dissolve the developed metallic silver, leaving the undeveloped light-sensitive silver compounds. These are then exposed to light, developed, and fixed as film is normally processed. This leaves a positive image where the blacks of the subject are black, and the whites are white.

A positive image can be projected onto a screen to produce a picture of the subject as it actually appears. Using a positive transparency to make a photographic print will produce a negative picture.

What Is Reduction?

Reduction is the photographic process used to remove excess silver from negatives. This technique is used to correct overexposed or overdeveloped negatives (negatives that are too dark).

The negative is treated with chemicals that change the metallic silver to soluble silver sulphate. When sufficient silver sulphate has been removed (when the negative has been reduced), the negative is removed from the reducing bath and placed in a solution of hypo. It is treated with the hypo for a few minutes and then washed in water.

Reduction is a process that is a matter of trial and error, and not all negatives can be corrected using reduction.

What Is Intensification?

The process of intensification is the opposite of reduction. Film that has been underexposed or underdeveloped does not have enough silver deposited to make a negative that can be used to make good prints.

To improve negatives that need more metal, compounds of silver, mercury, or chromium can be used to increase the amount of metal on the negative.

The process is complicated and some caution must be observed because of the nature of the chemical compounds employed.

Enlarging

Enlarging deals with bigness. It is the darkroom technique of producing large, framable pictures from negatives that are as small as a postage stamp. For the amateur photographer who has passed the introductory beginning of "darkroom magic," enlarging often becomes the favourite darkroom operation.

An enlarger is similar in many respects to a camera with the following difference: an enlarger is a camera-like piece of equipment that has been designed to project an external image onto a piece of light-sensitive paper. Cameras depend upon an internal image to make a picture.

Enlarging can be described as a form of photographic printing. Done in a darkroom, the image that leaves the enlarger lens strikes the light-sensitive paper. This is then developed in the same manner as photographic prints.

Experienced photographers have discovered that enlarging is not only the making of larger pictures from very small negatives, but is also a method of translating uninteresting, dull pictures into those that are exciting and closer to an illusion of beauty and interest.

For the beginner, however, it is better to leave enlarging to the professional. Any photographic dealer will for a "few pennies," make enlargements for you. You can, however, exercise some control over what you want enlarged and this will be discussed next.

Cropping Pictures

Any negative that has been correctly exposed and developed will make a good enlargement. As desired, you can have an entire negative enlarged or just a part of it. Sometimes by enlarging just a part of a negative you can eliminate areas not wanted that can spoil a finished picture.

This is known as cropping and is the elimination of some parts of a picture in order to improve the composition.

Cropping can be done without damage to the original print by using four straight edges to mark off the area to be enlarged. The print should be included along with the negative so the laboratory technician will know what area of the negative is to be enlarged.

colour photography

What is Colour?

In 1663, Sir Isaac Newton, experimenting with light, passed a ray of light through a glass prism (a piece of glass with three sides) and observed that as it passed through, it bent (changed direction—refracted) and separated into several different colours. Reversing this experiment, he passed the seven coloured rays through a second prism and discovered that white light appeared again. Modern science refers to the seven colours as a spectrum.

To understand what colour is, one must first accept the fact that white light is a mixture of seven colours—red, orange, yellow, green, blue, indigo, and violet. Since white light is a mixture of all the colours, then black can be described as the absence of colour. Science explains that white and black are not colours. They merely indicate the presence or absence of combinations of the seven colours that comprise the spectrum.

Then why, when we shine white light onto a red apple, does it appear red, and not white or some other colour? Coloured objects have the property of being able to absorb and reflect different light rays. When white light strikes a red apple, the apple absorbs all the colours except red. This it reflects, and

the apple appears red. That is why the leaves of a tree appear green; a yellow banana is yellow; a brown sweater is brown; etc. When an object is a mixture of several colours, the light reflected represents all of the colours in the object.

Being able to see colour is being able to see light. We have already learned that light is a mixture of colours, but how do colours differ from each other? Why, when light is passed through a prism, are we able to see red, orange, yellow, etc.?

The colours that make up white light are light rays of varying wave lengths. The longest is red, which is twice as long as violet, which is the shortest. As light passes through a prism, the shortest rays bend (refract) more than the longer rays and the result is a separation of light rays into different colours.

EXPERIMENT

How to Make a Spectrum

MATERIALS: A room that can be darkened (by placing sheets of cardboard over the windows); cardboard; masking tape; glass prism.

WHAT TO DO: Darken a room by fastening cardboard over the windows. Use masking tape to hold the cardboard in

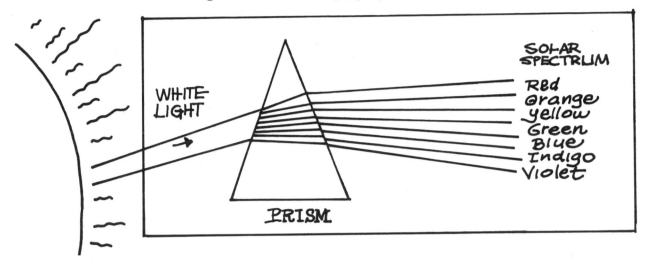

place. Punch a small hole in one of the cardboards so as to allow a thin beam of light to enter. Hold a glass prism in the beam of light and observe what happens.

WHAT HAPPENS: Review the previous section: What is Colour?

The beam of white light passing through the prism divides into a band of several colours, called a spectrum. If the room is too large, have another person hold a sheet of white cardboard to provide a surface on which the spectrum can be seen.

EXPERIMENT
Putting Spectrum Colours Together

MATERIALS: The materials from the previous experiment; a second glass prism.

WHAT TO DO: Place a second glass prism on the side of the first prism where the band of colours exists to shine on the wall. Observe what happens.

WHAT HAPPENS: The band of colours, called a spectrum, blends together to form the original beam of white light. It might be necessary to adjust the distance of the second prism to obtain the results wanted.

Seeing Colours

Colour is part of seeing light. Imagine the sun shining through a clear glass window. Letting through all the light, the colour appears as white. Changing the clear glass for one coloured red, all that will be seen is a red colour. The red glass prevents all colours except red from passing through. Repeat, using green glass, and only green will pass through. Holding the red glass in front of the green, black would appear. The red glass holds back the green and since there is no light of any colour passing through, we see only black. This is proof that white and black are not colours, but only mixtures or the absence of colours.

By the use of a spectrum, Newton proved that white light is a mixture of different colours. Why then do we see

only red light when white light passes through a piece of red glass?

Materials through which light will pass will absorb some of the colours, while others will pass through. This changes with the colour of the material used. This is known as the filtering effect of coloured materials, and those materials that are used to alter the colour of light are known as filters. More later about filters and their use in photography.

Colour created using different coloured glasses is called the *subtraction theory of creating colour*. The green glass subtracted all of the colours in the white light except the green and because red absorbs (subtracts) green, black resulted. Remember, white is the presence of all colours and black is the absence.

Another example of colour by subtraction occurs when two or more pigments (i.e., water colour paints) are mixed together to create a different colour. The residue that forms subtracts some colours, and reflects others—the result, a different colour. Mix red and yellow, and the reflected colour is orange. Blue and yellow combine to form green.

Colour can also be created by blending together coloured lights. Mixing together two or more light rays, each a different colour, will result in a still different colour. Known as the ADDITIVE PROCESS FOR CREATING COLOUR, examples are the mixing together (adding) of red and green to produce yellow. Red and blue, when added together, will make purple.

The part these colour processes (subtraction and addition) play, will be better understood after the next group of experiments and when colour film is discussed.

EXPERIMENT
Blending Colour by Addition

MATERIALS: Heavy cardboard disc about 4 inches in diameter; piece of string about 5 feet long; blue, red, and green crayons (or water colour paints).

WHAT TO DO: Carefully, using a small nail, make two holes in the cardboard, each about 3/16″ off centre.

Divide the disc into three equal parts, colouring each with a different colour—blue, red, and green. Suspend the disc onto the string by passing the string through one hole and then back through the other. Tie the string together and slide the disc so it is located in the middle of the string. The string should be at least 12″ long on each side of the disc.

Hold the ends of the string between the fingers and thumbs and spin the disc. Observe the colours and what happens.

WHAT HAPPENS: Instead of white, the colour that usually appears is a greyish-white. It will require some experimenting to produce a pure white colour because of impurities in the original colours used.

As the disc spins, the eyes retain for a fraction of a second an image of each colour, after it has spun out of view. This momentary vision is added to the next colour, and so on, to produce the final colour seen.

SOME SUGGESTIONS: Try investigating

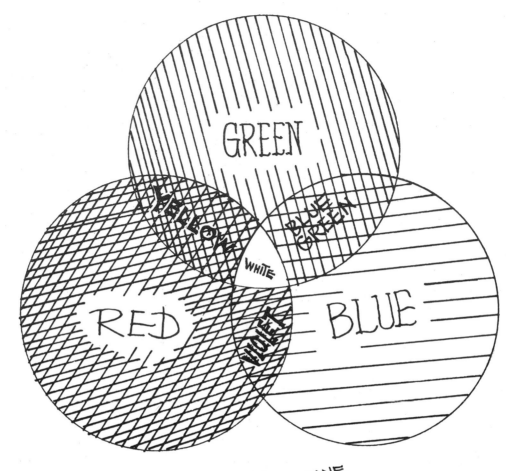

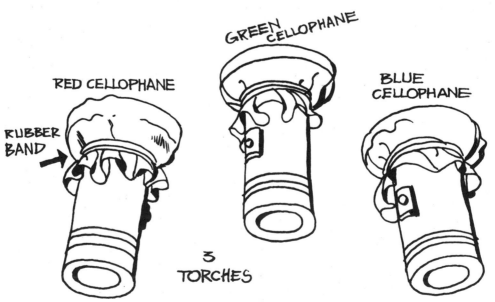

other colour combinations and see what happens. Red and green produce yellow; blue and red produce purple; blue and yellow produce green; green and blue produce peacock blue; etc.

EXPERIMENT

Colour Addition with Light

MATERIALS: Three torches; coloured pieces of cellophane (as described in WHAT TO DO); rubber bands; sheet of white cardboard.

WHAT TO DO: Cover the ends of three torches with different pieces of coloured cellophane, holding them in place with rubber bands. Turn on the torches and project the light onto a sheet of white cardboard. Let the inside circles of light from each torch overlap.

Observe the colours formed at the overlapping areas. Try using the following combinations to obtain the colours indicated.

With three torches, use red, green, and blue to produce white light. With two torches, use (1) red and green to create yellow; (2) blue and green to create a blue-green light; (3) blue and red to create purple; (4) blue and yellow to make green.

Unless coloured cellophane is used that is free from colour impurities, the colour wanted might not be very accurate.

WHAT HAPPENS: As with the colour disc of the previous experiment, colours formed by the blending together of different coloured lights is the additive process of colour formation.

EXPERIMENT

Colour Made by Subtraction

MATERIALS: Blue chalk; yellow chalk; red water colour paint; yellow water colour paint.

WHAT TO DO: Crush pieces of blue and yellow chalk and mix them together. Observe that the resulting colour is green. In a clean dish, mix together equal amounts of yellow and red paint to make orange.

WHAT HAPPENS: Reference to a spectrum colour chart will reveal that green is between yellow and blue in the spectrum. The yellow chalk absorbs (subtracts) all colours except yellow and green. The blue chalk in the mixture subtracts all colours except blue and green. Because the yellow and blue absorb (subtract) each other, this leaves green colour.

In the second dish, orange falls between yellow and red in the spectrum. The yellow subtracts all colours except yellow and orange. The red subtracts all colours except red and orange. The yellow and red (absorb) subtract each other, thus leaving the colour orange.

What Is Colour Photography?

Mention "colour photography" and the amateur photographer's first reaction is to say, "To take colour pictures requires special training, lots of experience, and advanced specialized equipment." This is not so.

Like black-and-white picture taking,

colour photography is also simple. Science has developed colour films that can be used with the simplest camera available. Taking colour pictures requires no additional adjustments. Just put the film in the camera, aim the camera at a subject, and gently squeeze the shutter. Photographers can also choose from films that will make colour prints (positives) or slides for projection.

Colour photography is the realization of a dream of many to be able to take pictures that are "alive" and as true a record as possible. It is photography that captures all the natural colour shades of the subject as they appear.

Colour photography does not require advanced specialised equipment. It takes a simple camera (which is nothing more than a box with a window at one end to let in light) with light-sensitive film. Only the film is different, as we will see later.

Colour Photography— Yesterday and Today

Colour photography had its beginning in the early part of the 19th century. However, it wasn't until 1892 in Dublin, that some practical success was realized. Two scientists, J. W. MacDonough and J. Joly, working apart from each other, discovered a method by which crude colour pictures could be made.

Ten years later, the Lumière Company, of France, invented a process of colour photography that proved to be very successful. For many years, using this process, it was possible to make excellent colour pictures with near-to-natural colours. Because this process, as well

as those invented prior to the method used today, was too complicated and highly involved, the explanation of how they worked will not be included here.

Around 1915, the Agfa Company invented a light-sensitive colour plate that was a great improvement over those of the Lumière Company.

During the early part of the 20th century, colour photography saw the introduction of many different processes. There were the Additive Process, the Subtractive Process, Duxochrome Process, Repeating Back Cameras, Dufaycolor, and many others.

In 1927, two musicians, both amateur photographers, had an idea. The original idea developed by L. Godowsky and L. D. Mannes was sold to Eastman who experimented with it for five years until it became a workable and easy process. Known as the Kodachrome process, it made colour photography a reality for many photographers.

What are Filters?

Before going into the subject of colour photography, there remains one more subject that must be explained. In addition to the special chemical components that enter into the construction of colour film, filters are an important controlling factor that allow colour film to capture a picture in all its natural beauty.

Filters are usually made from small pieces of coloured glass or plastic. Besides their use in colour photography, they are also used to control light in creating special lighting effects. For example, too much red in a sunset can be corrected by using a filter that will hold back (sub-

tract) some of the red and will let through the other colours.

Many simple cameras are not designed for use with filters. Using a filter to take a picture requires correcting the exposure to offset the decrease in light. The amount of exposure correction to be made is usually expressed as a number and is known as the filter factor for the filter being used. This factor varies with the choice of filters.

Examples of how filters are used to create special effects are as follows:

1 To "bring out the clouds" a *light yellow* filter is used. This filter holds back some of the blue in the sky that overpowers the white of the clouds. Using cloud filters requires an exposure correction of one and one-half times.

2 In close-up photography, a *yellow* filter is often used to increase the contrast between subjects that are light in colour and the sky. This filter requires the exposure to be doubled.

3 And if you want to make the sky even darker, almost black in colour, then a *red* filter must be used. This filter is used when it is necessary to emphasize detail in objects that are coloured red to reddish-brown. The exposure must be increased twelve times.

There are dozens of filters to choose from and choosing the right one depends upon the colour of the subject. Always remember that it is the colour of the filter that determines what colour light will pass through.

If you use a green filter to photograph a red flower, the result is liable to be no picture or, at most, an almost black picture with white leaves. By knowing what filters can do, one can use them to create many interesting effects.

Filters can also correct lighting conditions when the light might produce undesired effects. Examples are as follows:

1 Some colour films are designed for "outdoor use" and others for "indoor" picture taking. Filters can be used to decrease the amount of yellow in artificial light so outdoor film can be used indoors.

2 When copying old pictures that are faded and yellow in colour, try using a yellow filter. This will eliminate many of the stains and in most cases will help to increase contrast and produce more detail.

3 When the sun is too bright and might produce unwanted glare, there are filters that can be used to decrease the bright light.

4 If a haze holds back the light, anti-haze filters can be used to eliminate the haze, letting the light through.

EXPERIMENT

An Experiment with Filters

MATERIALS: Red, green, and blue cellophane.

WHAT TO DO: Hold a piece of red cellophane against the window and look through it. Everything looks red. Change the red cellophane for the blue, and everything looks as if it were coloured blue. Repeat, using the green cellophane.

With the green cellophane against the window, place the red cellophane on top of it. If the colour that appears surprises you, reread the section, Seeing Colours. Now try this part of the experi-

ment using the blue cellophane with the red on top. Are the results any different?

WHAT HAPPENS: Clear glass lets all the light waves that make up sunlight through. From an earlier discussion, sunlight (white light) consists of several different colours (spectrum). A transparent coloured substance such as the coloured cellophane used in this experiment filters the light. This is demonstrated when one looks through the red cellophane and only sees red. Red filters out (subtracts) the orange, yellow, green, blue, indigo, and violet, leaving only the red. The green filters out everything except green, and the blue allows only the blue waves to pass through.

When the red covers the green cellophane, it subtracts all colours except red. Since red has already been subtracted by the green cellophane, and the red cellophane subtracts the green, the result is black.

If a pure black colour does not appear, this is probably because the pieces of coloured cellophane used are not pure, absolute colours and do not absorb all of the light. In other words, the red cellophane might allow a few green or blue light waves through, the blue might let some of the green and red through, etc.

EXPERIMENT

Simple Filter Photography

MATERIALS: Light yellow cellophane; medium yellow cellophane; medium red cellophane; camera loaded with black-and-white film.

WHAT TO DO: On a bright sunny day, take the following pictures:

1 A picture of clouds.
2 Repeat the above holding the light yellow cellophane in front of the lens.
3 Repeat, using the medium yellow cellophane.
4 A picture of an object coloured red and green.
5 Repeat the above, holding the red cellophane in front of the lens.

WHAT HAPPENS: Pictures (1) and (4) are control pictures by which to measure the results of the other pictures.

Examination of pictures (2) and (3) will reveal that the clouds are much darker than in the control pictures, with the darkness increasing with the use of a darker yellow filter.

Yellow filters hold back some of the blue in the sky that overpowers the white of the clouds. Increasing the amount of yellow in the filters holds back more of the blue, producing "darker" clouds.

In picture (5) when compared to (4) the results are a picture with the red portions of the object accentuated and the green almost black. The red cellophane filters out all colours except the red and this is what is recorded on the film.

Since the camera you are using for this experiment probably will not be adjustable, do not be disappointed if your pictures are slightly underexposed. Simple cameras cannot be adjusted to compensate for use with filters, and this experiment is intended to demonstrate only what can be done with filters.

The Construction of Colour Film

Colour film, like black and white, consists of a thin sheet of flexible, transparent plastic coated on one side with light-sensitive silver compounds. Where black-and-white film has a single layer of silver bromide, colour film has several layers, each designed for a specific purpose.

A cross section view reveals that colour film has six layers, as follows: (1) an emulsion layer sensitive only to blue light; (2) a yellow filter that prevents excessive blue light from passing through; (3) an emulsion layer sensitive only to green; (4) an emulsion layer sensitive only to red; (5) a plastic base that supports the first four layers; and (6) an antihalo layer that absorbs excess light that might bounce back. The antihalo backing was described in greater detail when black-and-white film was discussed.

There Are Different Kinds of Colour Film

There are two kinds of colour film: (1) colour-reversal which makes positive colour transparencies (slides) that are looked at by placing them in slide viewers or by projecting them onto a screen; and (2) colour-negative that produces colour negatives that are used to make positive colour prints. However, colour prints can also be made from positive colour transparencies.

Until recently, most simple cameras were designed to use only colour-negative film. Kodacolor film, manufactured by Eastman Kodak, is a popular example of a colour-negative film. It is available in a variety of sizes.

However, during the past few years, there have become available simple cameras that can take pictures using both colour-negative and colour-reversal film. Eastman's Kodachrome and Ektachrome are popular examples. These will be discussed in greater detail later. There are also colour films by other manufacturers that can be used for colour picture photography.

How Colour Film Works

Colour-reversal film and colour-negative film are similar in construction. When exposed to light, which is a mixture of many colours, the following process occurs. Blue light, one of the primary colours, affects the first layer. As the light passes through the next layer, the yellow filter, any excess blue light is held back. The third layer, sensitive only to green, records an image of all the green parts of the subject. This leaves the fourth layer that is sensitive to only red light to record an image of any red that reflects from the subject. Red too is a primary colour. The three colours, blue, green, and red, when mixed together in correct amounts produce all the other colours.

To prevent the film from exposure by light that might bounce back, the plastic base is coated with a layer known as the antihalo backing. This backing contains a dye that absorbs any excess light.

How Colour Film Is Developed

Unlike black-and-white film, which uses

a simple developer to change the exposed silver compounds to metallic silver, *colour-negative film* requires a special developer and an involved chemical process when developing exposed film. The developer first changes the exposed silver compounds in each layer to metallic silver. The silver in each layer represents the colour and amount of light the layer was exposed to.

As the film is processed, coloured dyes form in each layer. Each layer contains a chemical compound known as a coupler, which combines with a chemical in the developer. These reactions produce a colour specific to each layer. The next step is to bleach out the metallic silver, leaving the coloured dyes that comprise the picture.

Instead of the original colours; blue, green, and red; complementary (opposite) colours are formed. Instead of blue, yellow is used for the first layer; magenta (bluish-red) replaces the green in the third layer; and cyan (bluish-green) instead of red in the fourth layer. These colours are difficult to see because of the orange tint that covers the negative. This colour serves to improve the colour quality of the final print.

Complementary colours are used because more natural colours are produced in the final print. When white light (which is a mixture of blue, green, and red) is passed through the negative, the colours act as filters and do the following: (1) the yellow dye holds back blue and lets red and green pass through; (2) the magenta holds back green, letting red and blue through; and (3) the cyan lets blue through; and (3) the cyan lets blue and green pass through as it holds back the red. The paper used to make colour prints from colour negatives is similar to the construction of film and is processed the same way.

Colour-reversal film makes positive transparencies (slides) that can be viewed by projecting white light through them or by making prints.

The developing process for colour-reversal film is a highly technical process that requires exacting care and control. It is not a process in which the amateur can expect to obtain successful results unless he is prepared to invest many thousands of pounds in the equipment required. For this reason, it is advisable that all pictures taken using colour-reversal film be developed by laboratories equipped and trained for colour film processing.

To illustrate what is required, a brief synopsis of how to develop a roll of Eastman's colour-positive Kodachrome film follows.

The film is first developed to form a black-and-white negative. It is then treated with a chemical known as a coupler, which will produce, after subsequent colour developing, the controlling colours: yellow, magenta, and cyan.

Next, the film is exposed to blue light and developed to form a positive yellow image in the blue-sensitive top (or first) layer. This procedure is repeated for the third (or green) layer and then for the fourth (or red) layer. The middle layer forms a magenta image and a cyan image appears in the bottom layer. Between all these steps there are numerous minor steps that include stop baths, hardening baths, washes, and rinses. Finally the negative silver particles that

remain are eliminated by a special bleach. The film is dried and you have a colour-positive.

What Kind of Film to Use

Any discussion of what kind of film to use must always begin with, "What kind of camera are you using?" If your camera is the old-fashioned roll film kind, then you probably will be limited to black-and-white and colour-negative film.

Some of the newer cameras, such as the Instamatic by Eastman Kodak, use a simple, easy-loading film cartridge. These are available with black-and-white, Kodacolor (colour-negative), and Kodachrome (colour-positive) film.

Since we have already discussed black-and-white film, we will limit ourselves to the two basic types of colour films. How the pictures are going to be used determines the selection of film. Negative colour film, like black-and-white, first makes negatives that must be used to make colour prints. No viewing equipment is necessary when looking at colour prints.

Colour-positive film makes colour transparencies (slides) that require viewing by projecting a light through the developed film. This can be a simple procedure by holding the slide up to a light. If one desires to see an enlarged picture, then a slide projector that will throw a larger image onto a screen must be used. There are also available small hand viewers. If colour prints are desired they can be made at a small extra cost.

If your camera will only take pictures using colour-negative film, there is a process by which positive transparencies can be made.

Colour Photography with the Simple Camera

Colour photography is an exciting step forward in picture taking. Many amateur photographers are often disappointed when they see their first colour photographs. You must always remember that unlike the human eye which balances and compensates to create an acceptable picture, the camera records only what it sees and the eye cannot correct a photograph to make it better.

Perhaps the most common mistake many photographers make is to allow colour to become dominant and overpower the main subject. Always try to remember that a good colour picture is one in which the colour helps the subject. Try to avoid situations where colour will detract from or change the story that you are trying to capture.

As for taking pictures using colour film and a simple camera, there are a few restrictions that must be kept in mind. Some of these are the time of day, the brightness of the sun, and the brightness of the subject. The manufacturers of colour film have spent much money, time, and effort in research to find how to take the best pictures. They have simplified this information into *what you should do* and *what you shouldn't do*. This information can be found on the general instruction sheet packed with the film. Always read it before taking pictures—it will help you take better pictures.

Have You Ever Taken Pictures Like These?

Many of the answers to why did my colour pictures turn out like these can be found by rereading the section, Have You Ever Taken Pictures Like These? Many mistakes made with colour film are identical to those made with black-and-white film.

However, when using colour film there are a few other reasons why poor pictures might result.

1 *Underexposure* produces pictures with very dark to almost black colours. The pictures are devoid of any detail. Check the batteries in the flash unit and make certain the film is not too old. If out of doors, make sure there is enough light.

2 *Overexposure* produces pictures that are pale, having washed-out colours, or no colour at all. The highlight areas have little or no detail. Overexposure is generally caused by too much light.

3 *Pictures have a yellow colour.* Daylight film might have been exposed using clear bulbs. Check the instruction sheet. It explains how to take pictures indoors using outdoor film.

4 *Pictures have a blue colour.* Indoor film that requires artificial light was probably used outdoors. Many simple cameras cannot be converted to use indoor film outdoors.

Colour Film Latitude

Black-and-white film has a wide latitude which allows a large deviation in an exposure and still produces a good picture. This is not true of colour film. It is very important that colour film is exposed with as little deviation as possible from recommended exposure settings.

When colour film is processed, some correction can be made for slight over and underexposure. However, when too much correction is necessary, it is best to take the picture over again.

Flash with Colour Film

The same principles that are used with black-and-white film apply to flash with colour film. With the simple camera and under average situations, flash with colour film has been reduced to a very simple, non-complicated photographic science.

In the beginning, most photographers will find themselves using films that require blue bulbs (i.e., AG1B, PF1B). Some of the newer films and/or flash units might require other bulbs. Your instruction sheet will contain the necessary information.

As with black-and-white photography, load your camera with film, put a flash bulb into your flash unit, make certain that you are standing the correct distance from the subject, aim your camera using your viewfinder, and squeeze the shutter. With a simple camera this is all that must be done to take colour pictures using flash.

a world of fun with photographs

Pictures say it all . . . the gaiety, the solemnity, the giving and sharing of occasions to be remembered . . . and just to make certain that you don't overlook someone you want to remember, your camera can be used to take pictures that will forever "remember for you." Whether it's a surprise party for a friend or a family dinner; a visit to the hospital to see the newest member of the family; or sports day at school, camera and film can be used to preserve memories of treasured moments and of other wonderful occasions.

Pictures can be used in many ways to make interesting and beautiful gifts. The suggestions and ideas that follow are but a few of the many ways to use photographs. With imagination and a few inexpensive materials, you can have a "world of fun with photographs."

First, Get Permission!

Sometime you might decide to sell one of your pictures, or enter it in a contest.

If your picture is one of people in general, such as people watching a parade or spectators cheering at a sports event, chances are that you will not have to get permission to use the photograph for commercial or contest purposes. If, however, the picture is one that was taken on private property, or of an individual person, or even of someone's pet, you should obtain written permission before releasing the picture for use other than your own personal enjoyment.

It doesn't matter whether or not you will profit from the picture, permission must be obtained. A policy followed by most photographers is to get permission to avoid any possibility of complications that might arise later.

People in general will usually cooperate after you explain to them how you propose to use the picture. They will often grant permission and accept a copy of the picture in return. Never use a picture for any purpose other than what was originally agreed upon.

An Old Favourite—Albums

Photographic albums are blank pages of paper fastened together between covers of heavier material to make a book into which photographs can be mounted. They are a way of protecting pictures against damage. Imagination can create many interesting effects when mounting pictures in albums. A few ideas follow.

1 *Holiday Albums.* Save all your holiday pictures and mount them in albums to make interesting picture-album records of holidays.

You might try mounting your pictures so that each page would show your holiday on a day-to-day basis, or so that each grouping would tell about a different event.

2 *Birthday and Dinner Parties.* Memories are wonderful and albums are a way of saving pictures that can be looked at in years to come. For example, use one album to mount pictures of your children's birthday parties. Be sure to indicate the year that each group represents. Don't forget to write in the names of those who were there. In years to come you will have priceless books of memories.

3 *General Albums.* You will probably accumulate many pictures that you want to save. Mounting them in albums with a few words that tell the story behind the picture, is better than just putting them in boxes where they can become damaged, lost, or just forgotten.

Make Your Own Album

There are many types of albums to choose from. Some can be purchased for very little, and there are some that are very expensive. However, it might be more fun to make your own album. The materials are inexpensive, and it is a fascinating project for a rainy day.

For a "giant" photo album like the one made by the author, you'll need two covers 18 inches by 24 inches from ¼-inch plywood. Be sure to buy plywood that is finished and sanded smooth on both sides. Place a narrow strip of plywood, ¾ inches wide by 24 inches long, next to each of the covers on the left side. Fasten them together using 1½-inch wide, self-sticking, adhesive cloth tape. Do not use plastic tape because it stretches.

At art supply stores, you can purchase coloured construction paper 18 inches wide by 24 inches long. Use this paper to fill your album. With your album filled, and the paper carefully aligned with the top, bottom, and left-hand edges of the book, carefully drill eight to ten holes through the narrow strips of plywood. The paper and album can then be held together by the use of leather laces threaded through the holes.

To make the covers more attractive, a light wood stain finish can be applied. Any hardware or paint dealer can furnish you with more information about the many different kinds of wood finishes available.

Titles and Captions Are Important

Having to stop to try and remember what a picture is about will often make pictures less appealing to those looking at them. Titles and captions of pictures should always be placed in albums (or included as part of the picture) when organizing groups of photographs into a special series of pictures.

When possible, if a sign is available that explains where you are taking a picture, either include it in your photograph or take a picture of it by itself to be included at a later date. When this is not possible, get out your little notebook, and make notes that will let you remember later what the pictures were about.

Having once identified the picture, you can write in the album below the picture any necessary titles and/or captions.

Make Your Own Christmas Cards

They are so easy to make—so personal—so exclusive! A Christmas photo card is far more personal than the ordinary printed kind because not only the message printed inside, but the picture too carries a most personal and cherished message.

You can select your favourite snapshot or slide and let any professional photographic finisher make your personal Christmas photo greeting cards. At a camera shop, you can pick out your Christmas card design from among many varied, gay, and beautiful selections. Any good photograph or slide can be used and if you don't have the negative, then for only a small charge you can have one made.

It's easy to get the right picture for use in making personal Christmas cards. Just group your subjects—children or the entire family—around an interesting point of focus: a piano, a doorway, a staircase, a fireplace, or in the living room. Try to bring into the background the festive spirit of the Christmas holiday.

When posing the family, remember to select a simple background; it's the people who are important and not the scenery. Avoid posed pictures with subjects forcing smiles or staring at the camera. Instead, try to catch people absorbed in the spirit of Christmas. Aim for big smiles or other natural facial expressions. Take close-ups. Remember that with your simple, non-adjustable camera you can get as close as 5 to 6 feet.

And if you want to make your own, you can purchase negatives that have appropriate messages and an area that will let you fasten a negative of the picture you want to use. You can even type a message on white paper, paste a positive print in place, and have it copied to make a negative.

With a suitable negative, all you have to do is make a positive print by exposing the negative and paper to light, develop the exposed paper, and let it dry. In this way you can make photo Christmas cards at a fraction of the cost of those made by professional photographic finishers.

How About Your Own Visiting Cards?

Visiting cards that are different, but still contain your name, address, and other necessary information along with a picture (when desired) offer an interesting project for anyone equipped to develop light-sensitive materials.

Any art or stationery shop has available white or black letters that can be used by pasting them onto cardboard or celluloid. Black letters should be pasted onto white cardboard and any art work necessary can be drawn using black ink. Have the finished "paste-up" copied to make a negative that can be used as in the previous experiment.

Black letters should be pasted onto clear celluloid. Any art work can be

done by using black paint or ink. When a picture is desired, cut out an area and fasten on a negative. When dry, you will have a negative that can be used to make your own visiting cards. It should be exposed and developed using the same procedure as a negative used for making photographic prints.

Other Greeting Cards, Invitations, etc.

Following the procedures explained in the previous two projects, prepare negatives changing the message for one appropriate to the occasion. With this technique you can make your own party invitations, picture baby announcements, picture bookplates, post cards, etc.

Growing Up with Photography

Memories can be beautiful. The family photographic album can be—and should be—a very important part of growing up. An album filled with pictures beginning with a visit to the hospital to see the newest addition to the family; special occasions such as birthday parties, graduations, weddings, and family reunions will help you to remember today what happened yesterday. Family albums can give much pleasure and now is the time to get started if you haven't already.

Wonderful moments occur in a fraction of time and it's impossible to remember all the details. Photography can be used to remember for you, what might never happen again.

Photography After Dark

Pictures taken after the sun has set and the skies are lit by the moon and stars can be unusual and refreshingly different. The following are a few ideas for photography after dark.

Learning about exposure when taking pictures at night, becomes a process of trial and error. Expect to waste a few rolls of film. Examination of your pictures and the recording of notes will provide exposure guides for future use.

Taking night pictures usually means using time exposure. This requires the equipment designed to provide a means of film support to eliminate camera movement that would result in blurred pictures. A handy gadget is the Kodak Flexiclamp, a sort of C-clamp with a tripod screw that can be attached to many objects. It is small and easily fits into a gadget bag.

With your camera loaded with film (try colour film for the best results) and securely fastened to prevent movement, you are ready to step forth into the realm of photography after dark.

Brightly lighted rides at carnivals can be photographed to produce interesting and dramatic pattern pictures. Try a time exposure of 1 second, 2 seconds, and 3 seconds. By counting to yourself the expression "one thousand and one," etc., you can approximate a second of time.

Fireworks at night are easy to photograph. Merely aim your camera at a place in the sky where the bursts of light are likely to appear and open your shutter. If there is a delay between

bursts of light, hold a piece of cardboard in front of the lens, removing it only when the next display appears.

Automobile headlights make fascinating pictures. Merely make certain that your camera is securely fastened and open the shutter for approximately six minutes. The lights of the automobiles driving through a busy intersection will create a very interesting picture. Many pictures of this sort have won prizes.

By reference to the following, a general idea for length of exposure can usually be determined. Of course, every situation is different and some experimenting might be necessary.

1 *Fires such as bonfires, campfires, burning buildings* require an exposure of 1 to 2 seconds. Try 1 second first.

2 *Neon signs* should be exposed from 1 to 3 seconds. Try 2 seconds first.

3 *Brightly lighted street scenes* must be exposed for about 30 seconds in order to obtain good pictures. A little experimenting might be necessary. Don't be afraid of wet streets or rain, they can make very interesting and dramatic pictures.

4 *Shop windows* generally require an exposure time of approximately 2 to 3 seconds. Make certain that you obtain permission first!

5 *Buildings lighted by floodlights* generally require 30 seconds if very close, and as you move away, the time of exposure must be increased proportionally.

6 *Outside Christmas lighting on houses* can generally be recorded on film when using a time exposure from 15 to 30 seconds. Try the shorter time exposure first.

7 *For inside Christmas tree decorations* try an exposure time of 2 seconds. This records the decorative lights. To include the overall detail of the decorations, follow through by firing a flashbulb.

Unexpected Pictures

All that is necessary to take some of the best pictures is patience. By keeping your camera available, you can capture on film some of the funniest pictures—such as the changing facial expressions of young children. You can't create these situations, you just have to be ready to take the picture when you see a good moment.

Some of the most humorous pictures ever taken involve situations surrounding pets. The simple act of giving a kitten a ball of wool can produce possibilities for many good pictures.

A good picture must have the spark of life, the beauty of motion, and simplicity. Above all, pictures should always tell a story. Unexpected pictures produce the feeling that the situation actually exists. Advice cannot be given on how to set up your camera to take unexpected pictures. These are the hardest kinds of pictures to take. Hours of watching and waiting may only result in a few pictures, but they will be worth it.

Some Suggestions for Posing People

Posing people for picture taking is a limitless subject. The author, through many years of experience, has decided upon a few general ground rules that

are summarized as follows. Try them as you decide upon your own techniques. They might help to create better pictures.

1 *Baby Pictures*

Get as close as you can. Details of different situations that surround a baby often can produce many interesting story-telling pictures. Try taking a picture of the baby being bathed. Pictures taken of details such as a tiny foot being washed; a hand reaching for a toy; a nose covered with soap; etc. can create some of the funniest and/or most interesting pictures you will ever take. Although you can't control situations or expressions, chances are you will have situations occurring that will create "real" pictures.

2 *A Favourite Theme is Loneliness*

Mostly, though, good pictures result from being aware of people and their surroundings. Everyone, at some time in his life, feels lonely. Loneliness, captured on film, can be translated into pictures that tell stories that are often otherwise forgotten.

3 *Try Facial Contortions*

Words are not needed to share humour. Taking pictures of people making faces will produce pictures that are humorous and interesting. Snapping the shutter after eating a lemon; or when someone yells "skunk." Pulling on the face, or covering it with a nylon stocking can create facial contortions that are different. Try taking pictures of people making "funny faces," and you may be surprised at the results.

4 *Geometric Patterns*

The sun shining on a pond; a bottle of milk spilled onto the ground; pebbles on a beach; refuse left over after a picnic; just about anything can be photographed to produce an interesting pattern picture. You cannot arrange the subject matter of a pattern picture. You have to be ready to take a picture as you watch for, look for, and recognize subject matter that will make an interesting picture. Don't be surprised, if when looking at finished pictures they produce comments of emotion and solemnity.

5 *Pictures of Flowers*

Try taking pictures of your favourite flowers in the early morning when the sun is not too hot and the flowers are in full bloom. Carefully sprinkle a few drops of water onto the leaves and blossoms to replace early morning dew. Avoid cluttered backgrounds by having someone hold a sheet of cardboard in back of the flower. Move in as close as your camera will permit and take the picture.

6 *Try Out-of-Focus Pictures*

Believe it or not, certain subjects make far more interesting pictures if they are slightly out of focus. Try a picture or two, taking it normally and then one that is slightly out of focus. Have them developed and you be the judge. Remember, looking at pictures is a matter of interpretation and you will have to decide if you like it. It does not hurt to experiment.

7 *Inanimate Objects*

The following are a few of the many objects that have proven to be potential photographic material. Many pictures

have been taken of these subjects and you might find it of interest to try it also. Cups and saucers, each set different from the other; glassware; table settings; the sand and pebbles of a beach; construction of buildings, particularly of those being built of structural steel; trees; ghost town pictures; the dramatic results of burned-out fires; almost anything that does not move, with the right background can produce an interesting and dramatic picture. All you need is to be able to recognize the occasion as well as the subject matter at hand.

Decorating with Pictures

Finished photographs can be used for creating projects that are both fun and profit making. The first—fun—will be described. The latter—profit—will be left to your own invention and design.

Pictures can give new life to many old objects. The necessary materials are finished prints, sharp scissors, mounting cement; a ruler; pencil; the object to be covered; imagination.

Before beginning, the subject of mounting pictures should be briefly described. From experience, it has been found that there are three mounting mediums that have generally proven successful. They are: (1) Photographic Mounting Cement, a material designed for mounting pictures which is used as any other adhesive; (2) ordinary rubber cement that is used by applying a thin coat to the photograph and a thin coat to the surface onto which the print is to be mounted. Let both coats of cement dry and then carefully place the picture in position; it will stick in place; and (3) Dry Mounting Tissue, which is tissue paper chemically treated so as to form a bonding surface between picture and mounting surface when mild heat is applied. Follow the simple directions supplied with dry mounting tissue when using it.

The first step in decorating objects with photographs is to decide which ones you will use. Then proceed to measure out a pattern and cut out the prints. Using adhesive, fasten them in place. Don't be in a rush; take your time and the results can produce many an interesting conversation piece.

A few of the objects that can be covered are lampshades, light switches, tops of tables and desks, wastepaper baskets, paperweights, jewel boxes, walls of rooms, etc.

Try Wrapping Gifts with Photography

A personal touch to someone special often means more than the gift itself. Try fastening a picture of the person for whom the gift is intended onto the packet and watch the results. And if you receive the gift, then say, "Thank you" using a photograph of yourself enjoying the contents of the package with a few words written on the back. Personal touches mean so much that the most inexpensive gift can often come to mean as much as one that costs much more. Try it and watch the results.

Making Photograms

Photograms are shadowlike photographs

Photogram.

made by placing objects onto a sheet of light-sensitive paper and exposing them to a source of light. They are then developed in the same manner as photographic prints. Photograms are simple to make. A camera is not necessary. The only materials needed are sheets of photographic paper; an assortment of miscellaneous articles such as paper clips, pencils, pins, silverware, etc.; and developing solutions.

For exposing the paper you will need a 25-watt bulb set at least 2 to 3 feet above the paper. Pour your solutions into the trays: (1) developer in the first tray; (2) short-stop in the second; and (3) hypo in the third—and you are ready to begin.

With only the safelight turned on, place a sheet of light-sensitive photographic paper on a flat surface, emulsion side up. Arrange on it different articles. You might try paper clips, pins, a pencil or two, etc. Imagination can create ideas that are endless. Turn on the light and expose the paper for a few seconds. Turn off the light, remove the articles, and develop. It might be necessary to experiment with the exposure time to obtain a good black-and-white contrast. With practice and experiment, you

should be able to create photograms that are excellent conversation pieces.

Travel and Holiday Souvenir Booklets

An easy way to show the interesting highlights of your travel and holiday pictures is to mount them into pocket-size photo albums.

Art supply and stationery shops often have available small spiral-bound notebooks that can be used as photo albums. Arrange your pictures into groups, so that each set relates a different story. Mount the pictures into a book, making certain that appropriate titles and any other descriptive information are included.

If you want to start from scratch, purchase sheets of art paper. Cut them to size and after the pictures have been mounted, the pages can be bound. Look in the classified phone book under *Book Binders* for a spiral binding company.

The cover of the book should be marked with the name of the place visited and the date.

So You Want to Show Off Your Pictures

Albums have already been discussed. There are many ways to let people see your photographs. Besides using them as decorations (already described), why not try making a *picture gallery?* It requires either heavy cardboard or thin plywood (depending upon the size); cloth tape (or metal hinges if wood is used); mounting cement; and imagination.

Begin by cutting from heavy card-

board two pieces each 15 inches by 7 inches, and one piece 14 inches by 16 inches Using cloth tape (plastic stretches) fasten to the sides of the larger piece of cardboard one of the smaller pieces. This makes a free standing screen that can be covered using different materials. Select the photographs that you want to display and fasten them to the screen using cement or dry mounting tissue.

And if you want to make a larger picture gallery screen, just double or triple the dimensions. Use plywood instead of cardboard and replace the cloth tape with metal hinges. Use at least three hinges for each side. Sand the plywood smooth and stain it, using wood stain, or cover with self-sticking plastic or paper. Mount your pictures, step back and let your friends admire the results.

Another Way to Display Your Pictures

Obtain a sheet of pegboard and have it framed using 1 inch square or one-quarter round pine. Prepare the surface of the pegboard by painting. When dry, fasten it onto a wall and using wire clips that you can purchase at any art supply store, hang your prints up so that others may look at them.

Or you can purchase from any photography store white cardboard frames into which you can place a photograph. These frames can be displayed by sliding them into a groove cut into 1-inch strips of pine that have been mounted onto a flat surface. This is the type of display most generally used at art and photo graphic exhibits.

Taking Pictures of the Stars

With your camera loaded with film Medium Speed (125 ASA) and mounted so that it cannot be moved, an interesting experiment to try is taking pictures of the stars.

First, it will be necessary to locate the North Star and use the viewfinder to aim the camera towards it. Unlike the other stars, the North Star remains in about the same place. Other stars revolve in a circle around the North Star once in every 24 hours. Making a time exposure of 4 hours will result in a picture of the star trails that are one-sixth of a complete circle.

Time exposures at night should be done only when the camera is protected from accidental exposure from street and automobile lights. Star photographs should be taken only on moonless nights.

The shutter of the camera should be set on time and the exposure made using the largest opening (when there is a choice possible). When finished, don't forget to close the shutter.

Moon Pictures

How many times have you wanted to take pictures of something different? Using a simple, non-adjustable box camera loaded with a medium speed film, excellent pictures of the moon in all its phases can be taken.

All you need do is mount your camera so as to prevent it from being moved and make certain that it is protected from accidental exposure to street and car lights. The camera should be placed in as dark a place as possible.

If your camera has settings that must be adjusted, then set it at its slowest "instantaneous speed" and the largest lens opening. All that remains is to snap the shutter.

For the second part of this experiment, you will require a camera that is *not* designed to prevent double exposures on the same piece of film. With the camera in a non-movable position, try taking a series of several pictures on the same piece of film. Do not wind the film after each exposure. Make your exposures at 10-minute intervals. This will result in a multiple exposure (picture) of the moon in different positions.

Using a non-adjustable camera for moon photography might require some experimenting. If your pictures are underexposed, try a faster film such as Tri-X or increase the exposure time by using time exposure.

Some Ideas for Other Projects That Use Photographs

You have been introduced to several projects using photographs as a form of decoration. A good picture has always been a valuable treasure. With a camera you can make lasting pictures of whatever interests you—your family, places you visit, personal collections of treasured items, pets, friends, etc. No other hobby gives you so much. How you use finished photographic prints depends upon your imagination. Listed below are several ideas for other projects which you can easily make. Many of them you will want to keep as mementos of treasured moments. Some you might want to use as special gifts for special friends.

You will find other ideas in some of the books listed in the next chapter. Read them; they will help to broaden your photographic knowledge. A few of the more popular ideas suggested by the author are as follows:

1 *For Your Own Personal Use*
Picture Bookplates. Obtain a bookplate and mount onto it a photograph of yourself. Have it copied to produce a negative that you can use to make prints from.

Picture Baby Announcements. Print all the details about the new baby and mount a picture onto a card. Photograph it and use the negative to make personalized baby announcements.

Who Am I Pins? Mount photographs of yourself onto large pins. If you are running for school or political office, they can be used very effectively. You might try mounting a photograph onto a piece of heavy cardboard and then with adhesive tape fasten an ordinary safety pin on the back.

2 *Toys and Games You Can Make*
Picture Puzzles. Select the photograph you want to use and have it enlarged. Mount it on heavy cardboard and with a jigsaw (or hand coping saw) cut it up into irregular pieces to make a jigsaw puzzle.

Picture Mobile. Using colorful pictures of different places, separate them into pairs and mount them back to back on very thin wood (1/8 inch is satisfactory). Cut out the pictures according to the shape desired. Sand the edges and coat, using a clear acrylic lacquer spray. Drill a small hole through the top centre of each piece. Assemble the mobile by bending coat hanger wire into an appro-

priate shape. Next, hang the photographs on the main hanger using 9- to 10-inch lengths of fine wire, and you will have a finished mobile that can be used as a wonderful gift.

3 *Documentary Photography*

Insurance Records. What better way is there to describe a valuable object that has been stolen than by using a photograph? Insurance record pictures are not intended as artistic masterpieces. The object is a clear picture that reveals all details. Select a camera angle where distortion is at a minimum and set your lights to produce the least amount of shadow. To authenticate the size, a ruler can be included in the photograph.

Valuable Documents. It is not necessary to make prints; negatives can be stored in appropriately marked envelopes that can be kept in a safe deposit box. So often we only have a single copy of a valuable paper and photography provides us with a way to have several copies at very little cost.

4 *Offbeat Photography*

Textured Photographs. From your local glazier, purchase a sheet of textured glass. Try taking pictures holding this glass in front of your subject. Depending upon the type of glass used, you can create pictures that range from the offbeat comic to an almost horror-scare photograph. To avoid glare, try using bounce light wherever possible. By using backlighting, you can create entirely different effects. Another controlling factor is that the farther the subject is from the glass, the more blurred the image will be; the closer the distance, the greater the detail.

Silhouette Portraits. This is not a project of special materials. All that is required is a slight change in the way the picture is taken. The subject should be placed in front of a neutral background. Using an ordinary lamp (unseen by the camera), arrange it so it is behind the subject and shines onto the background. Develop the prints so as to be certain that the exposed area will become completely black. This means a slight increase in developing time. Fix and wash the print as you do other prints, and the result is a silhouette.

Pencil Torch Artistry. Load your camera with Tri-X film and mount it so it can't be moved. Turn out the lights, and with your subject sketching in the air with a pencil torch, open the shutter and take a picture using time exposure. Try an initial exposure time of 10 seconds and then make other exposures increased by a few seconds to determine the correct exposure time for your camera. Make certain that the torch is aimed directly at the camera. If you want to include the person doing the sketching, fire a flash bulb just before you close the shutter.

5 *And Now You're on Your Own.*

magic with photography

The photographs that follow have all hung in International Exhibitions or won National awards, and represent the best of their kind. You should now have the basic knowledge of the art and science of photography: with awareness and practice should come photographs as exciting and as good as these.

"Sultry Girl" *by Joe Bates, Jersey.*

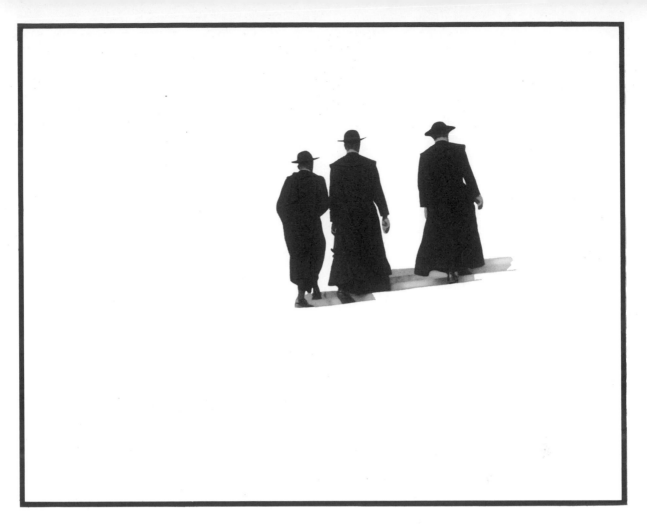

"Ascension" *by C. L. Morris, Staffordshire.*

"Dünen" *by Klaus Flöter, Berlin.*

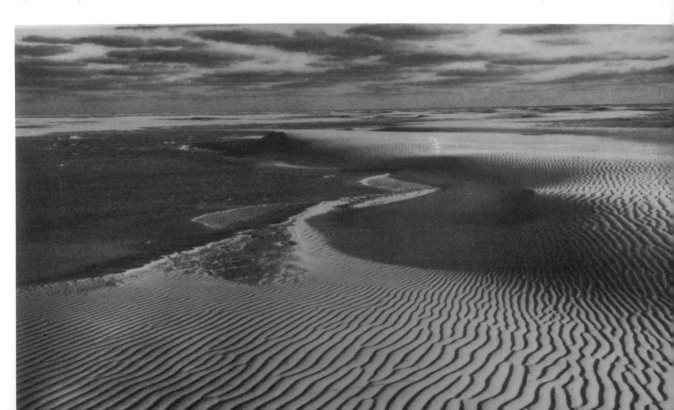

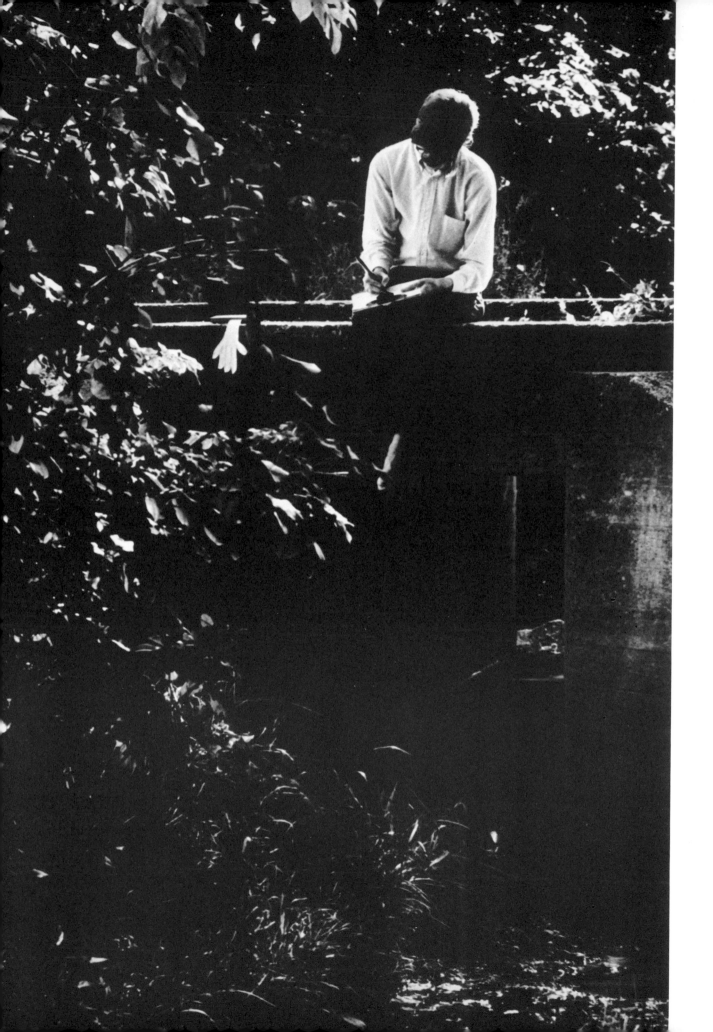

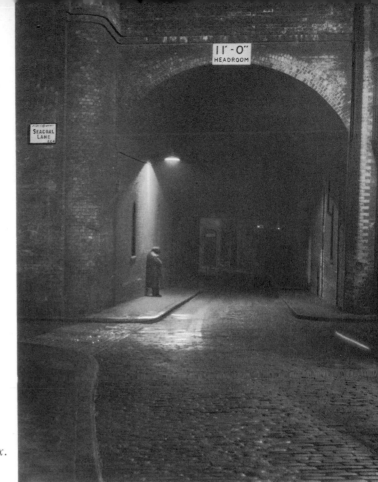

"Michael" *by Emily Wheeler, Virginia, U.S.A.*

"Sea Coal Lane" *by F. Brown, Middlesex.*

"Sea Ballet" *by W. Adams, Perth, Scotland.*

"The Thinker" *by Eric Berger, California, U.S.A.*

"Old Wharf" *by Christopher Fry, California, U.S.A.*

"The Gorbals Story" *by J. F. Logan, Kilsyth, Scotland.*

The opening photograph is an enlargement of a section of this photograph. For the photographer this was a treasure in an abandoned house, in some overgrown field.

PAUL H. LEVIN

NOTES